穆 星

很多人對我的認識就是廣告男模

在電視上報紙上常出席各式各樣的活動場合

表面上看起來光鮮亮麗的

但私底下的我其實就是一個普通的上班族

下班後也會到健身房報到

所有的休假都拿來接通告

幾乎用盡所有的時間在正職與兼職的工作上

因為我相信對份內工作沒有辦法全力以赴的人

沒有資格談論夢想！

在 23 歲可以為自己留下些什麼？

或許也可以是很不一樣的自己！

BLUEMEN

NO.14

穆星

享受這一大片草原給的寧靜與自由
彷彿這個世界裡的一切都停止了
只希望這一刻
有你在我身邊

Enjoy the tranquility and freedom of this large grass
It seems everything in this world has stopped
I only hope this moment
Have you by my side.

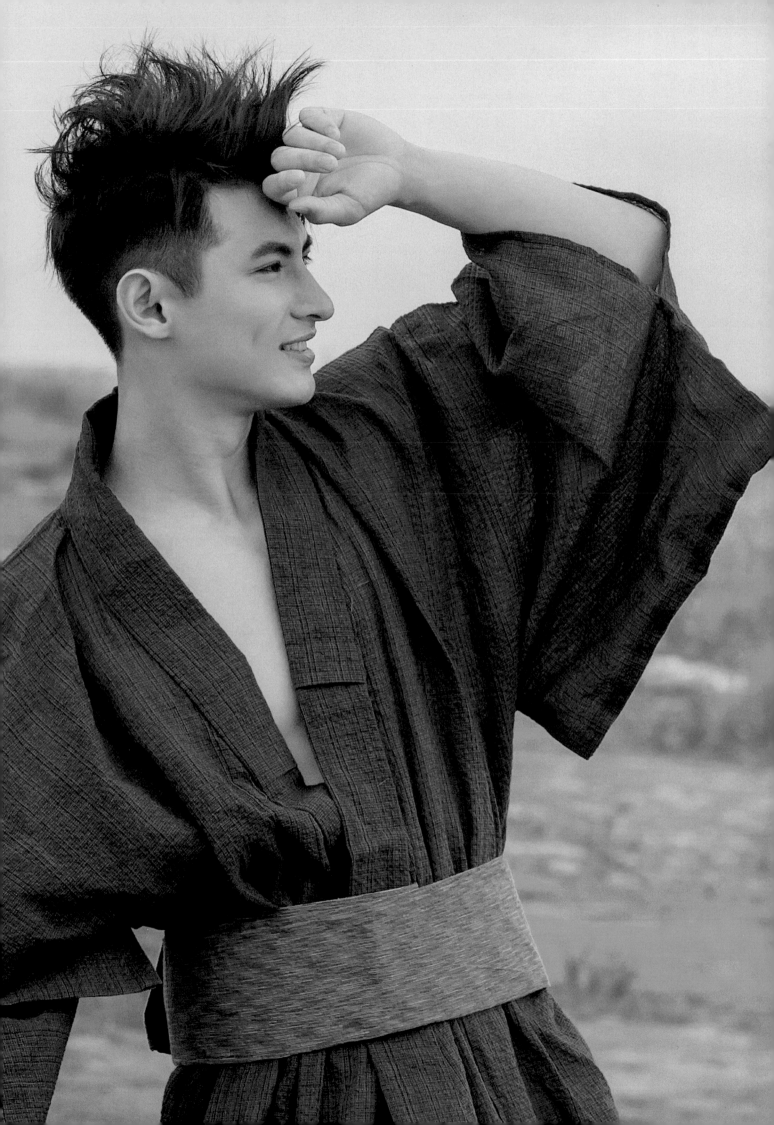

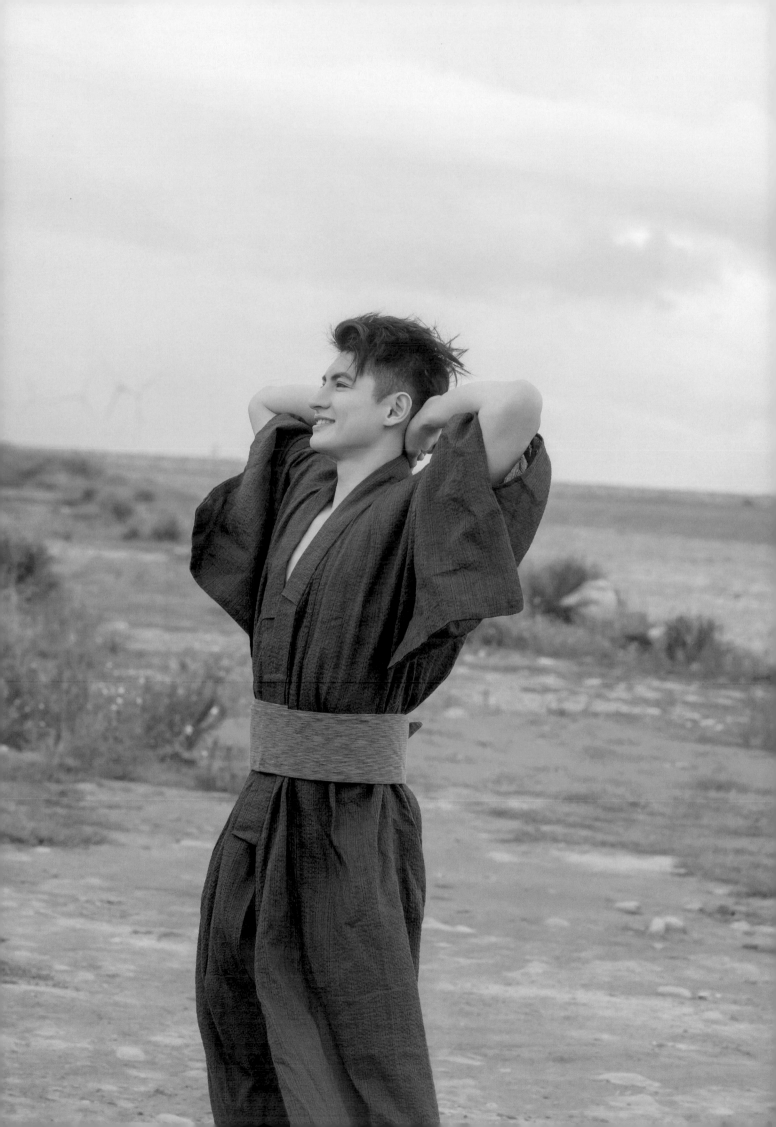

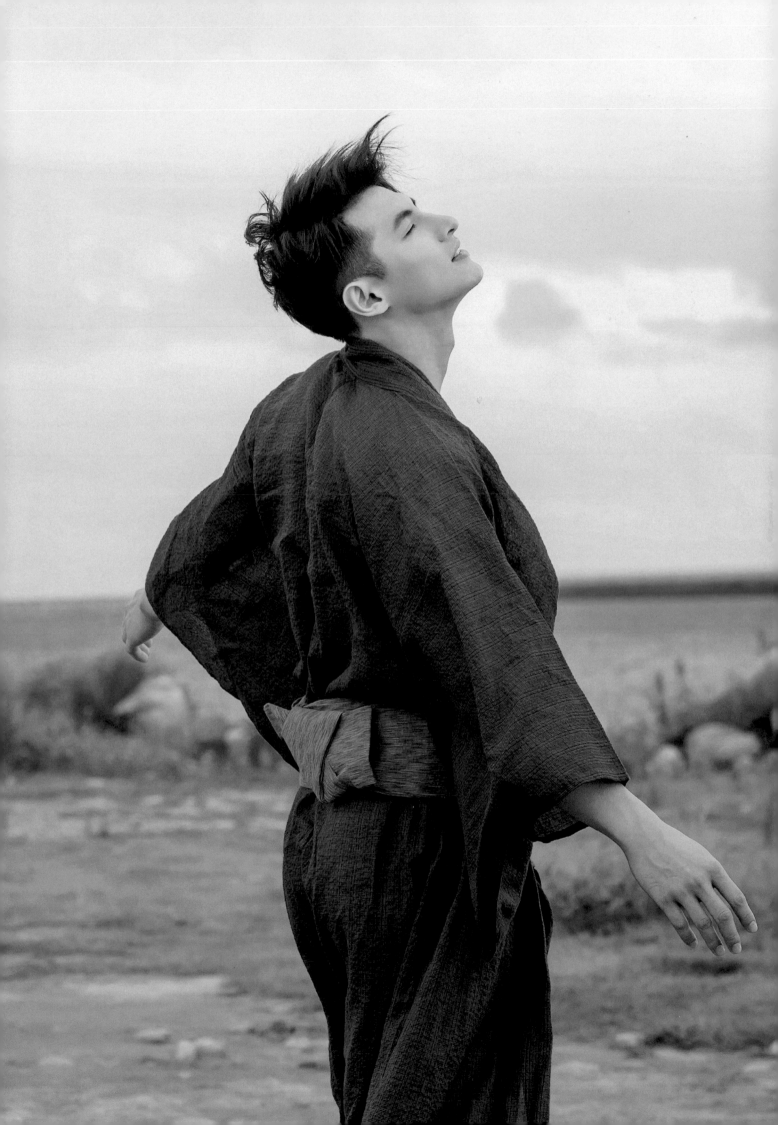

FREEDOM

IS NOT

A

DIFFICULT

THING

———

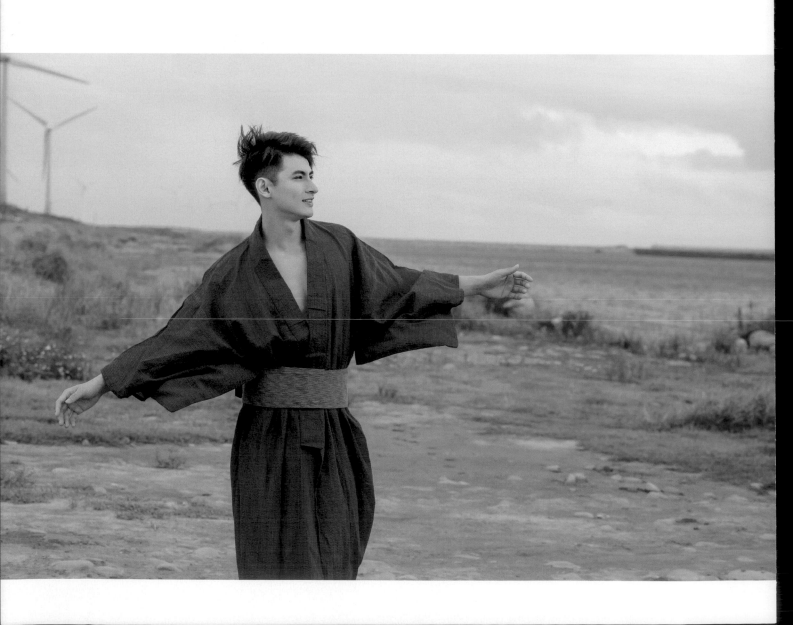

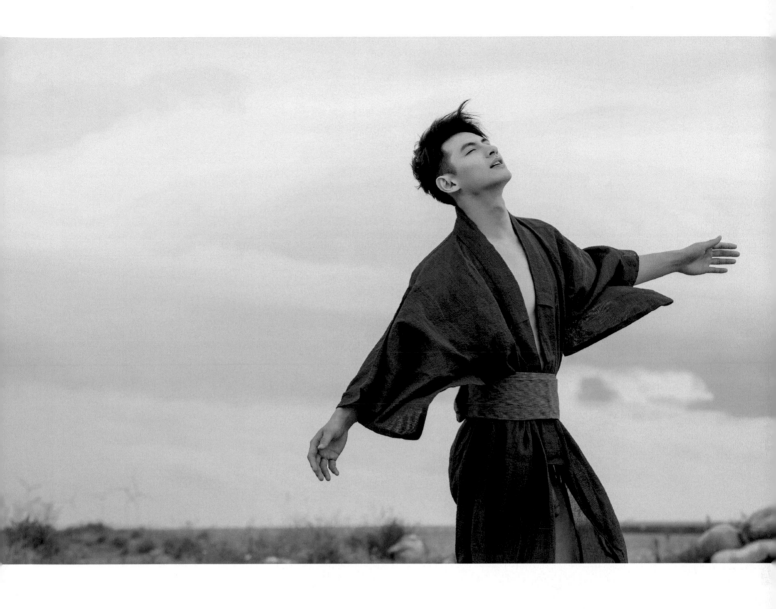

I CAN FEEL

FREEDOM

AND

YOUR
HEART BEAT

>

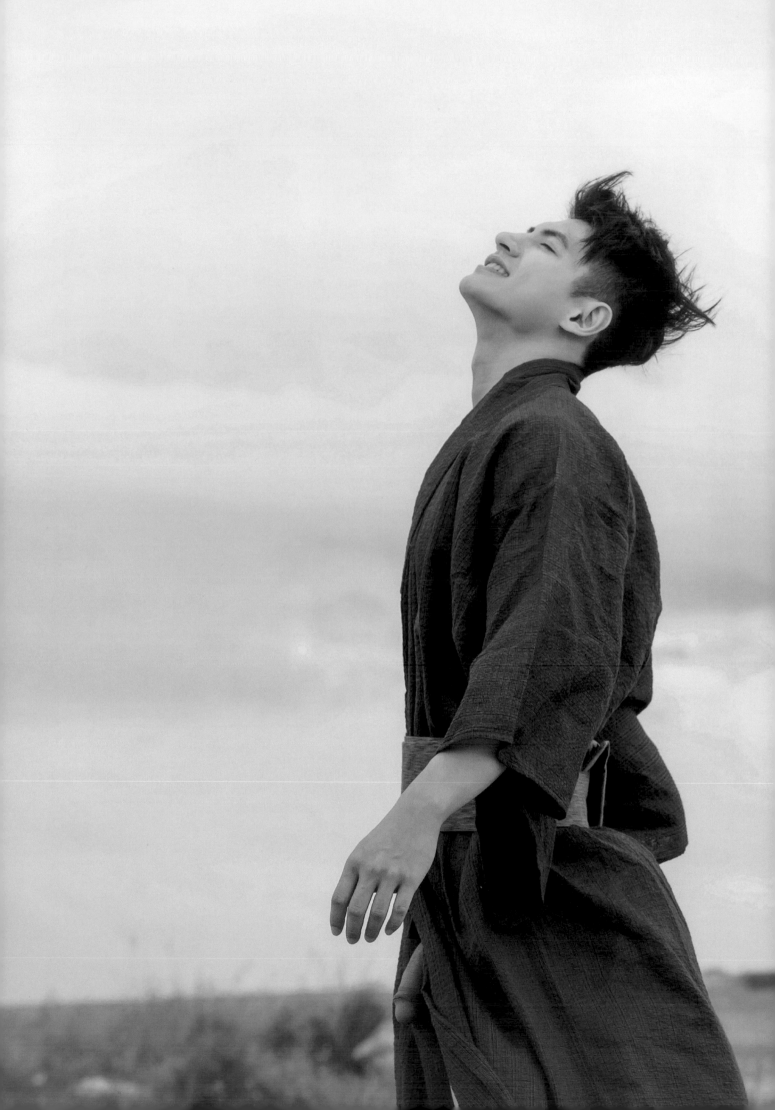

我喜歡

這一望無際的天空

它似乎正慢慢拉近

我和你的距離

我也慢慢能感受到

你手心的溫度

I LOVE THIS SKY

IT SEEMS TO BRING ME TO

CLOSE TO YOU

AND I CAN FEEL

THE TEMPERATURE FORM YOUR TOUCH

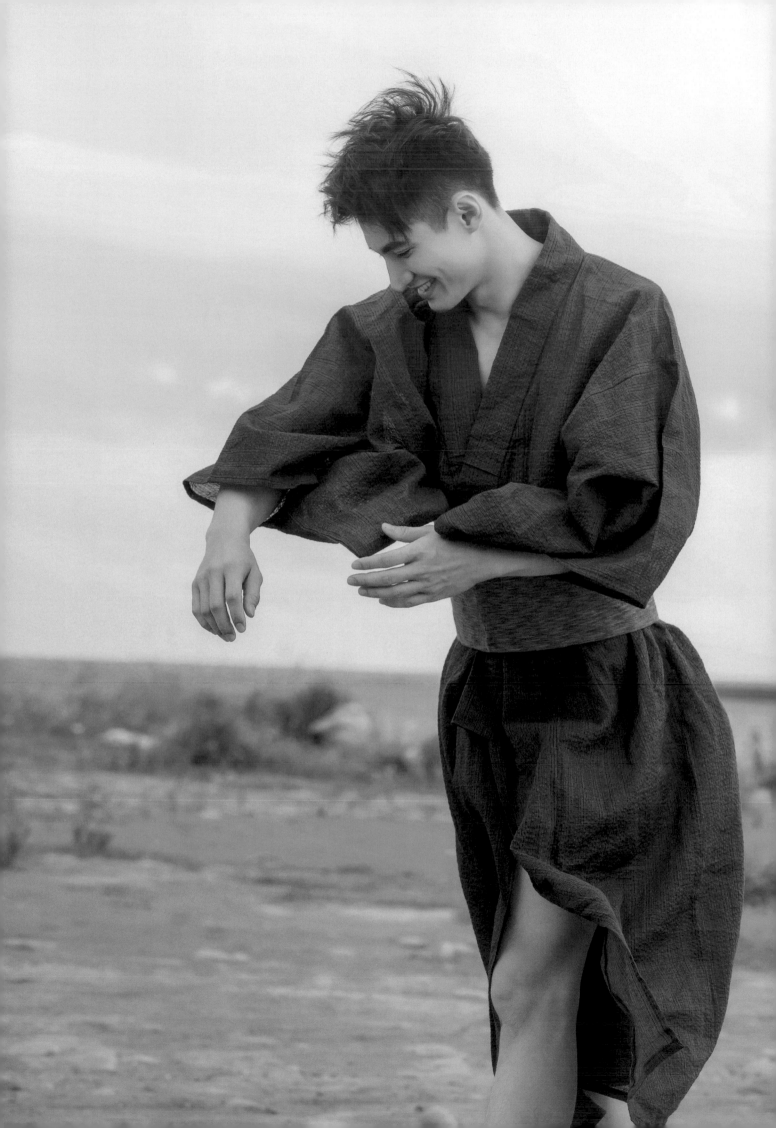

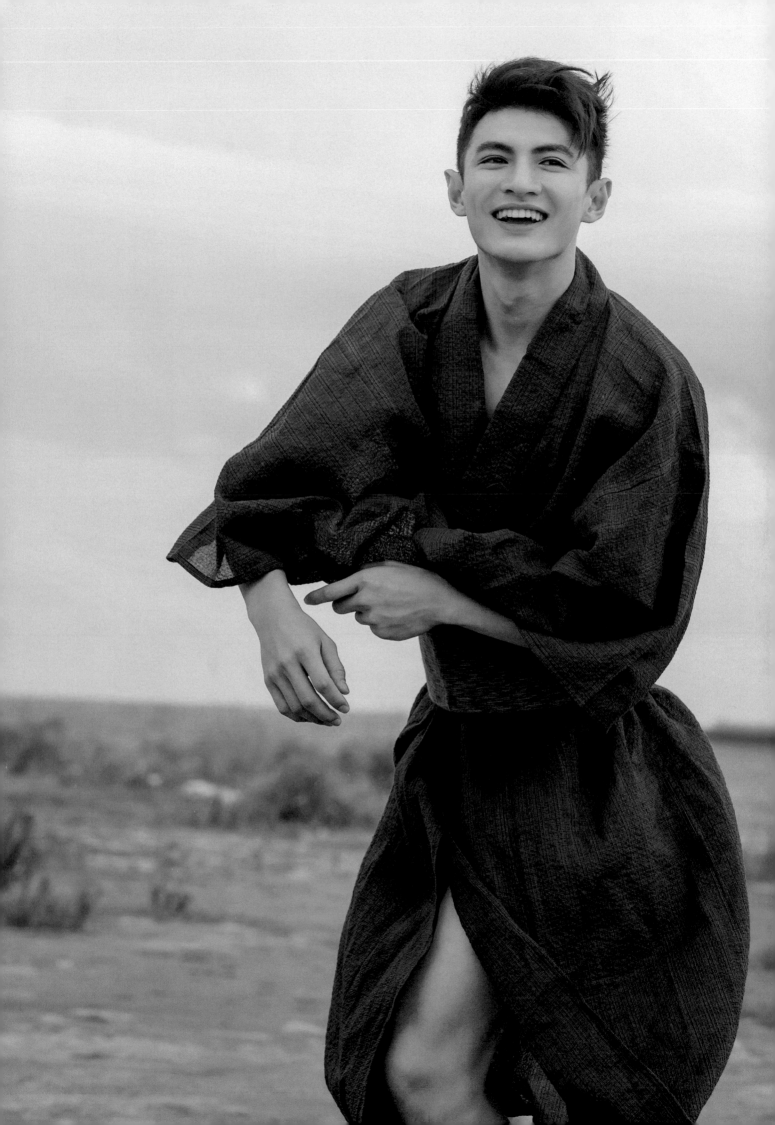

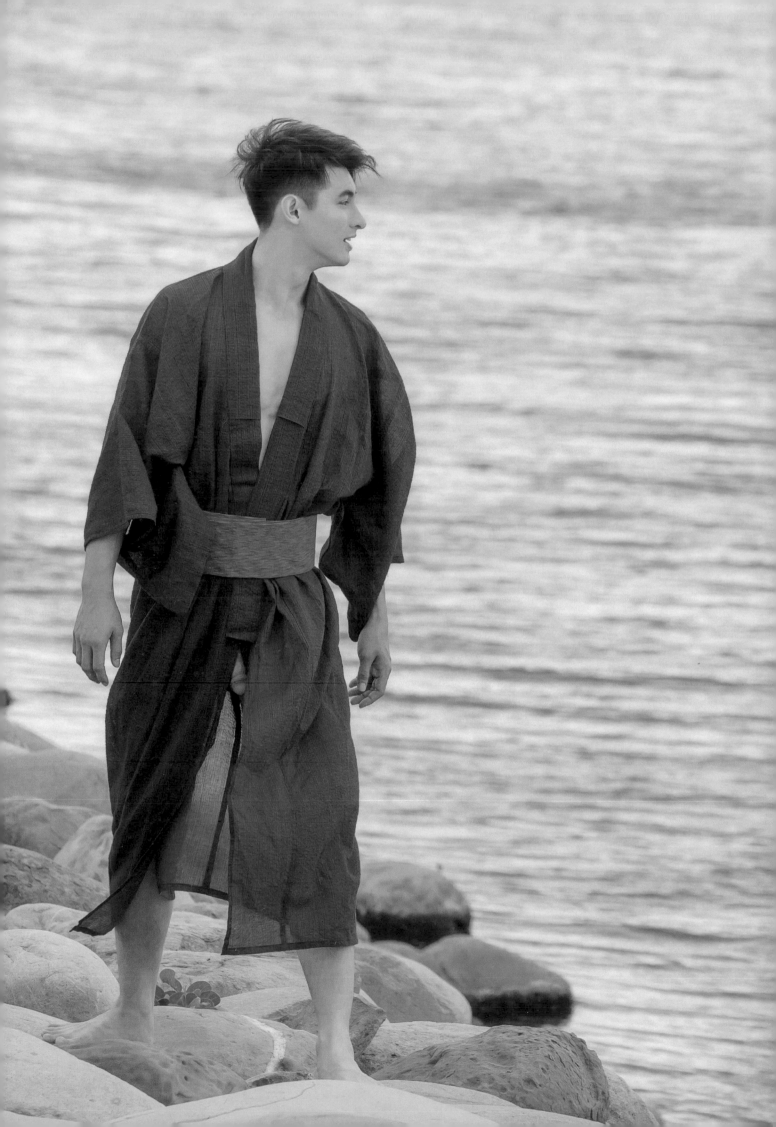

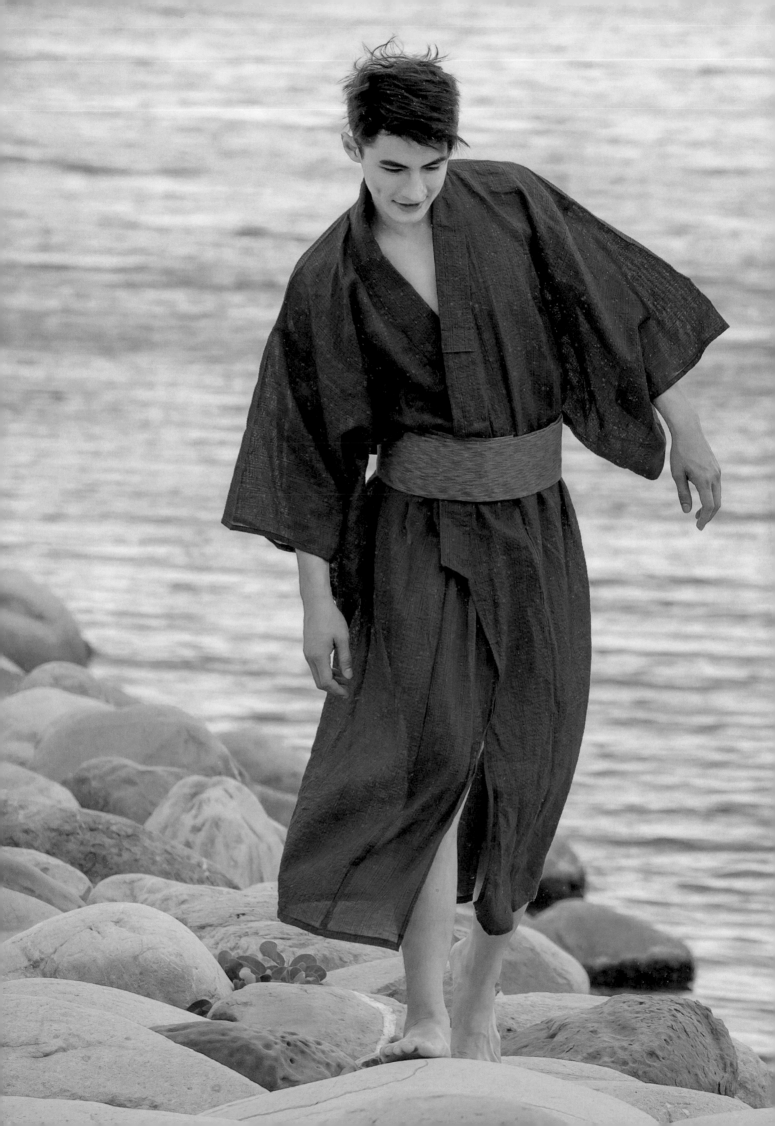

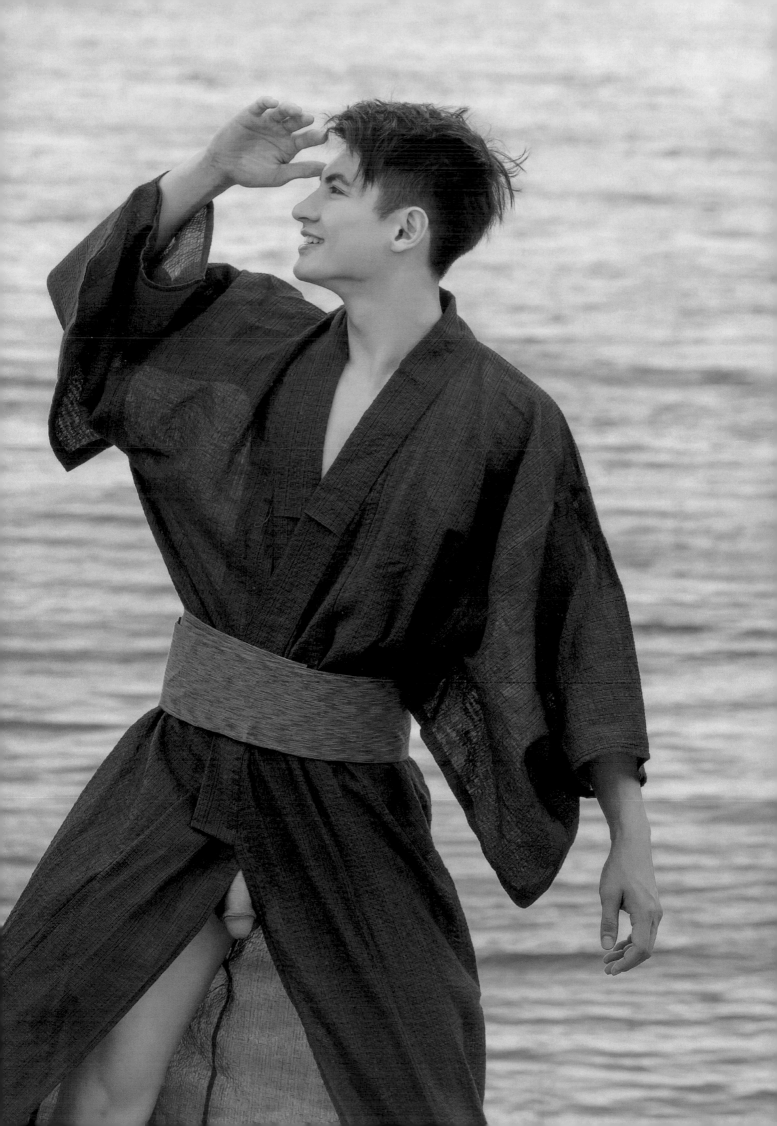

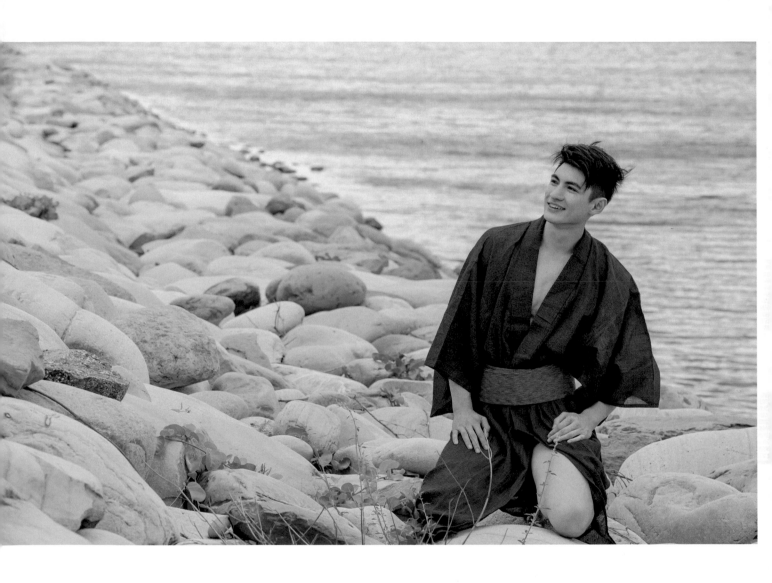

JUST　FEEL

Following the natural

Breathing together, enjoying together

It is also a good way to let me relax.

CALMLY
FACE
EVERYTHING
AROUND
YOU

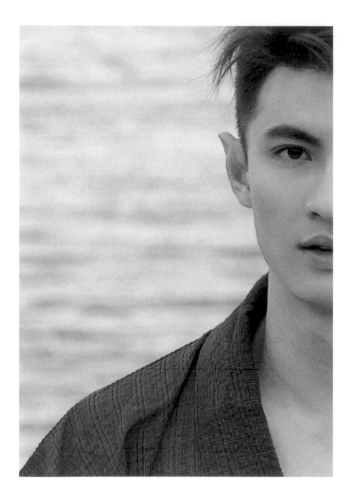

BLOCK
UNNECESSARY
EMOTIONS

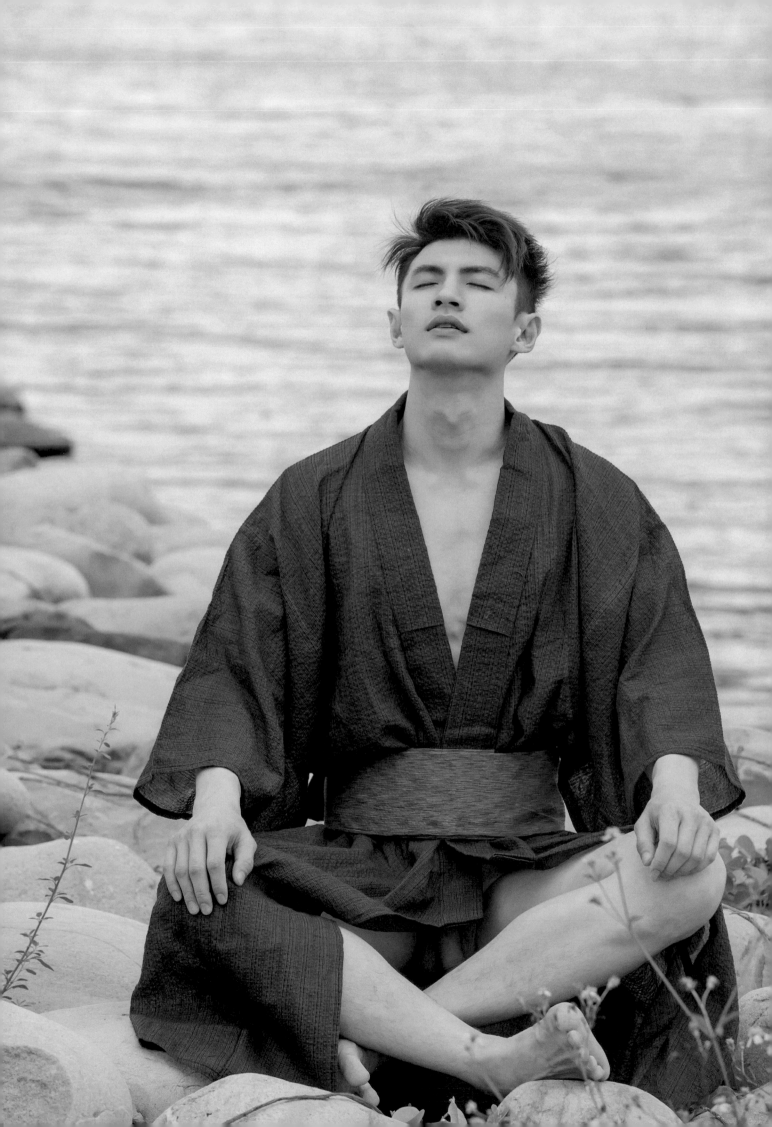

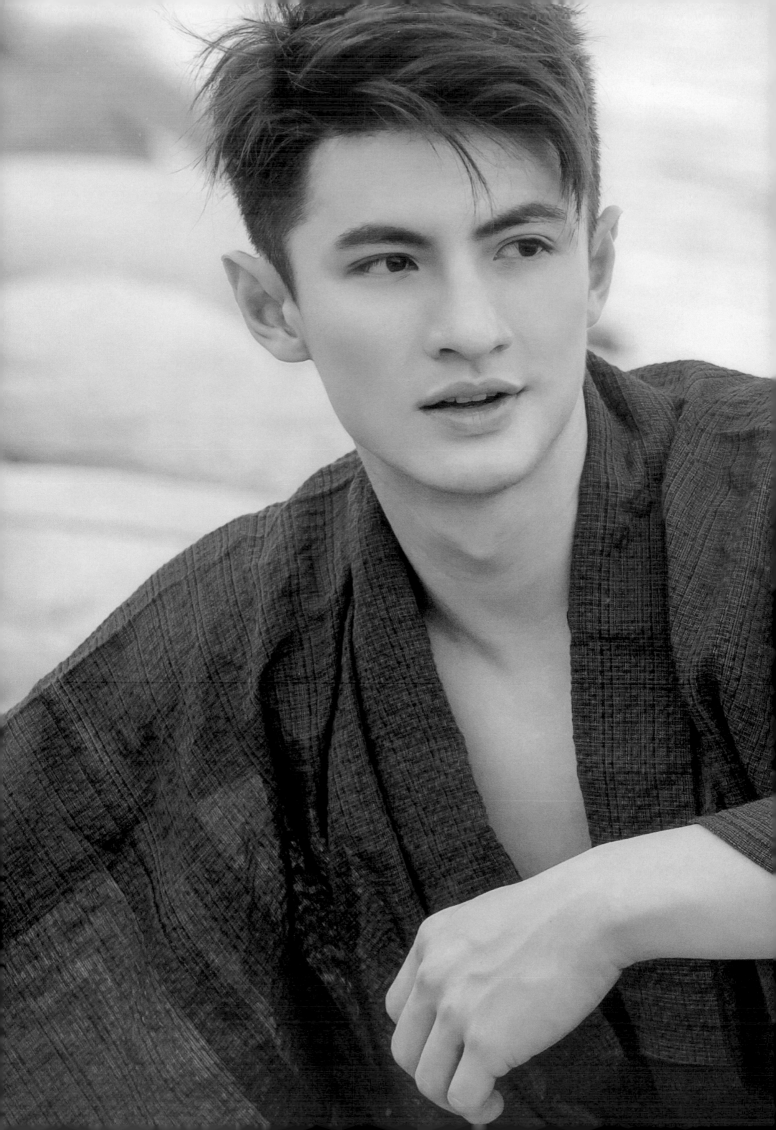

BLUE MEN

NO.14

穆 星

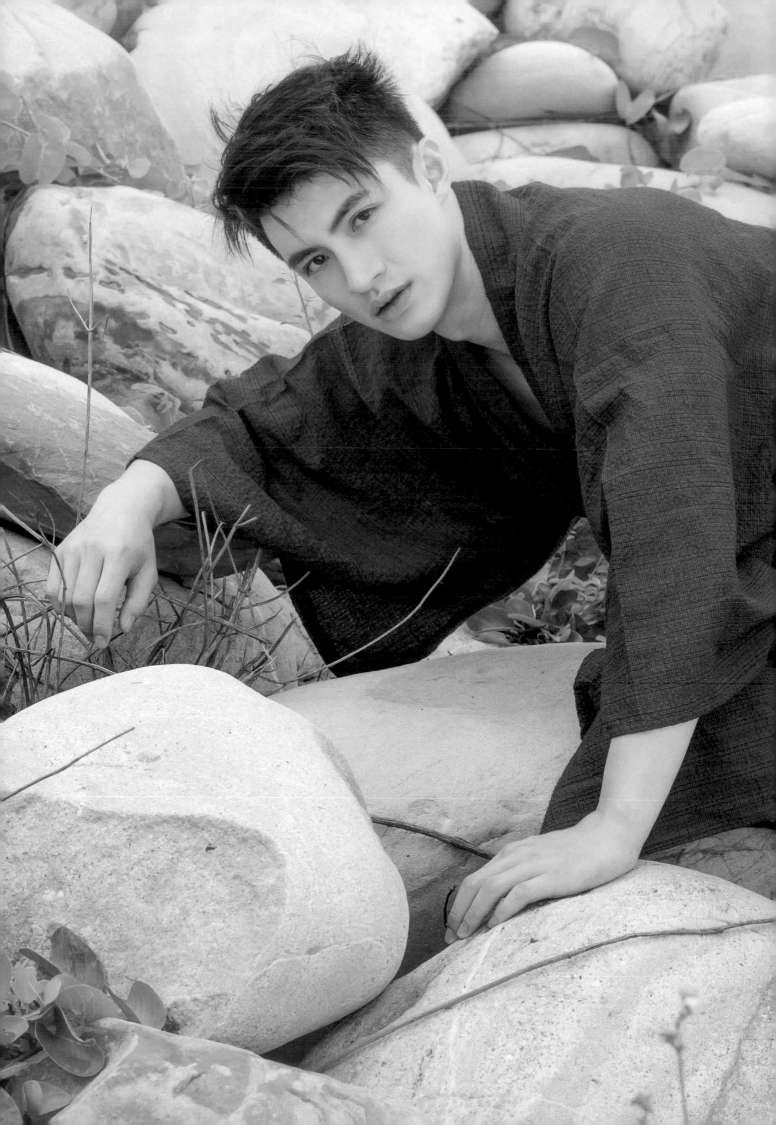

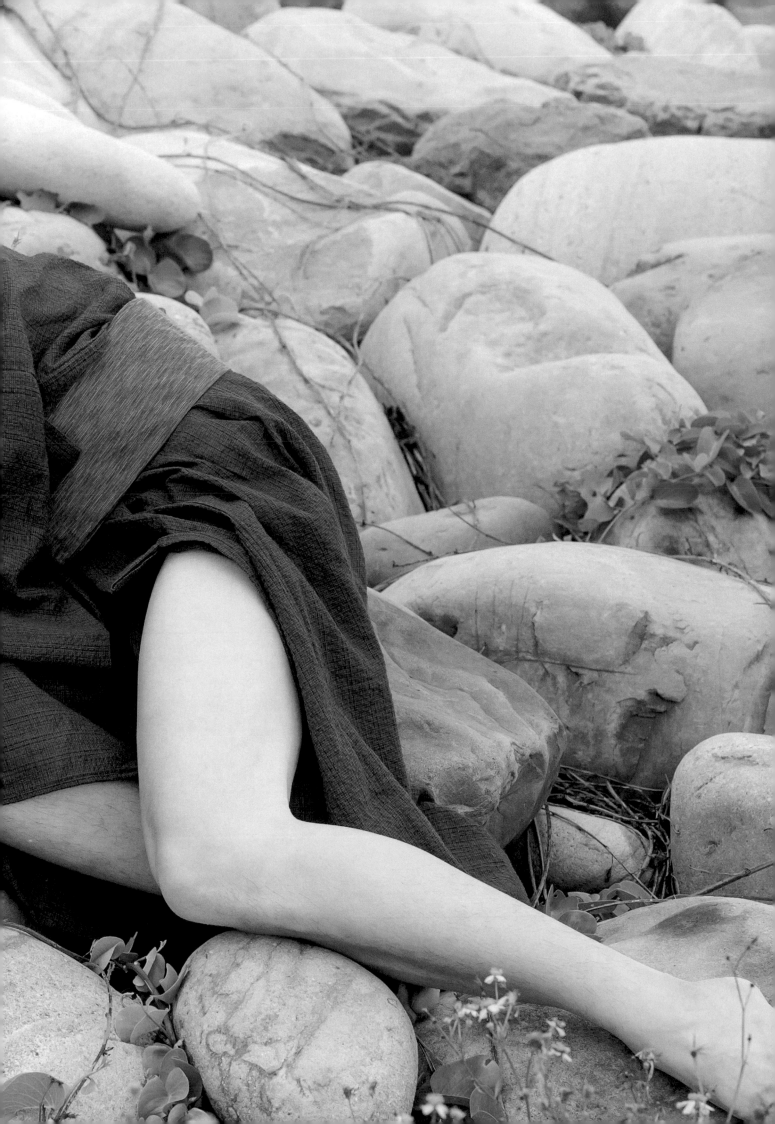

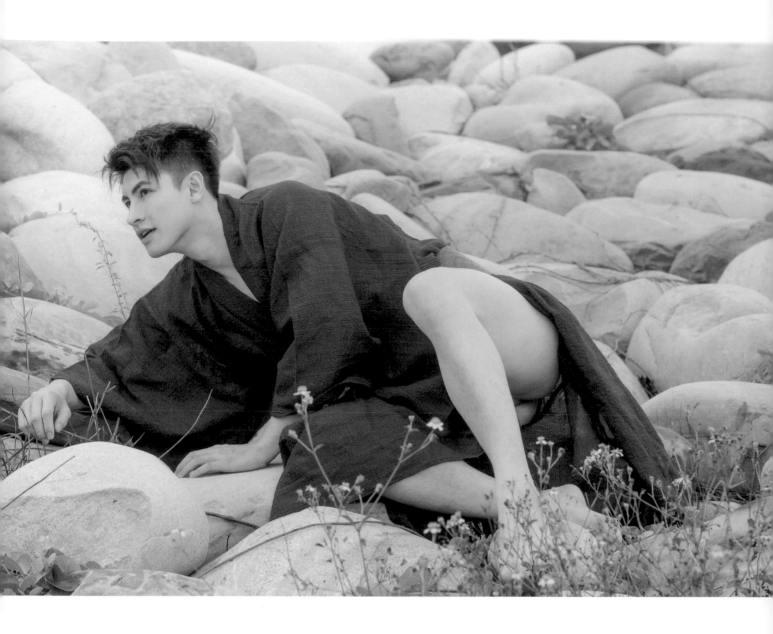

JUST
ENJOY
THIS
MOMENT

THEN
FEEL
WHAT
I AM
FEELING

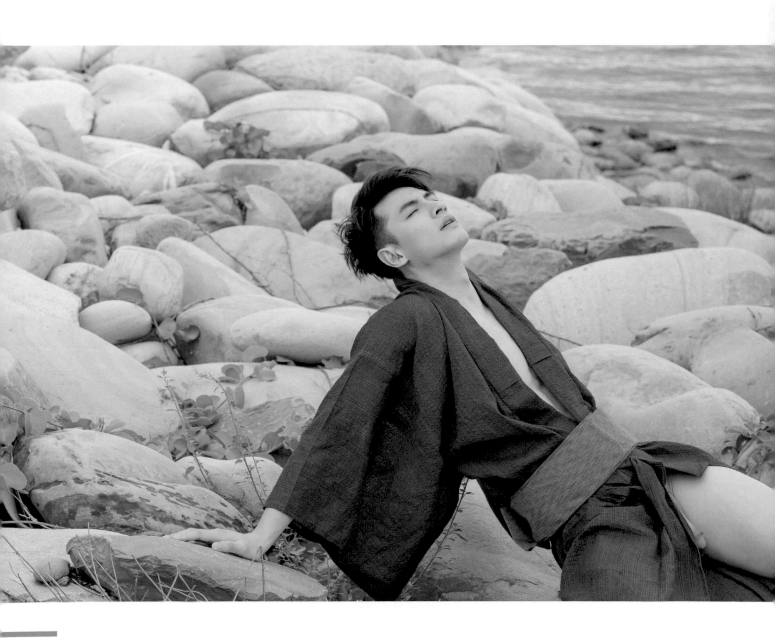

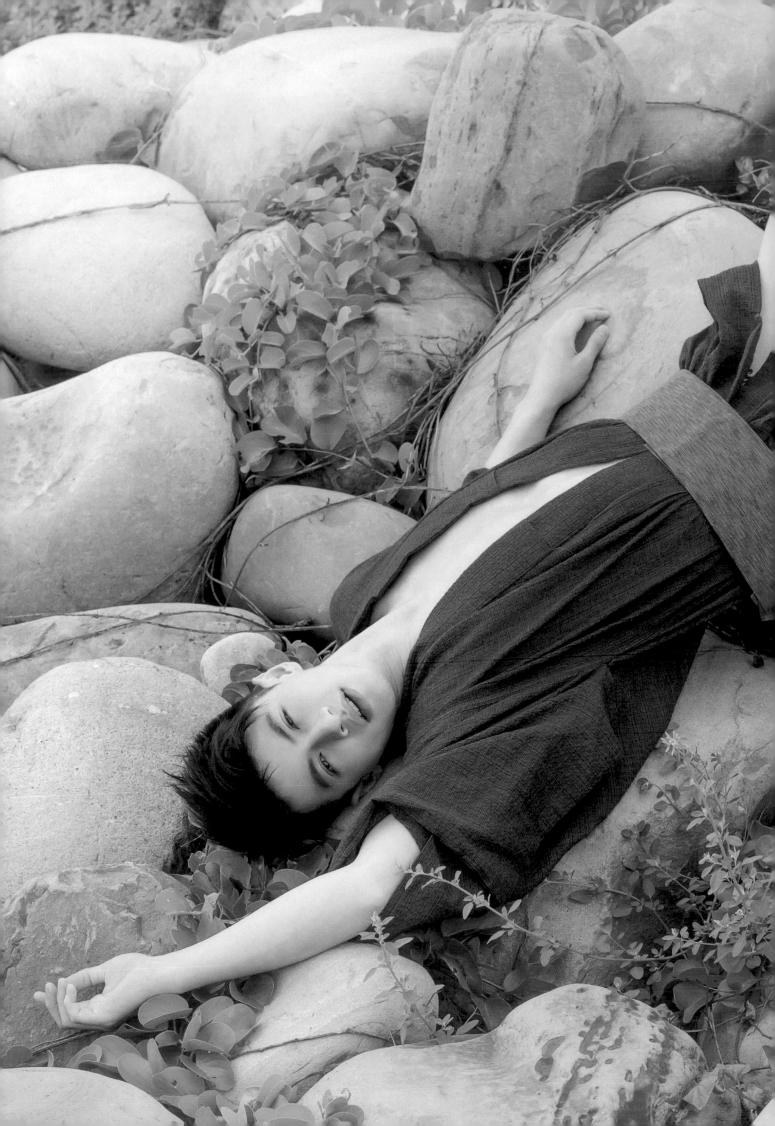

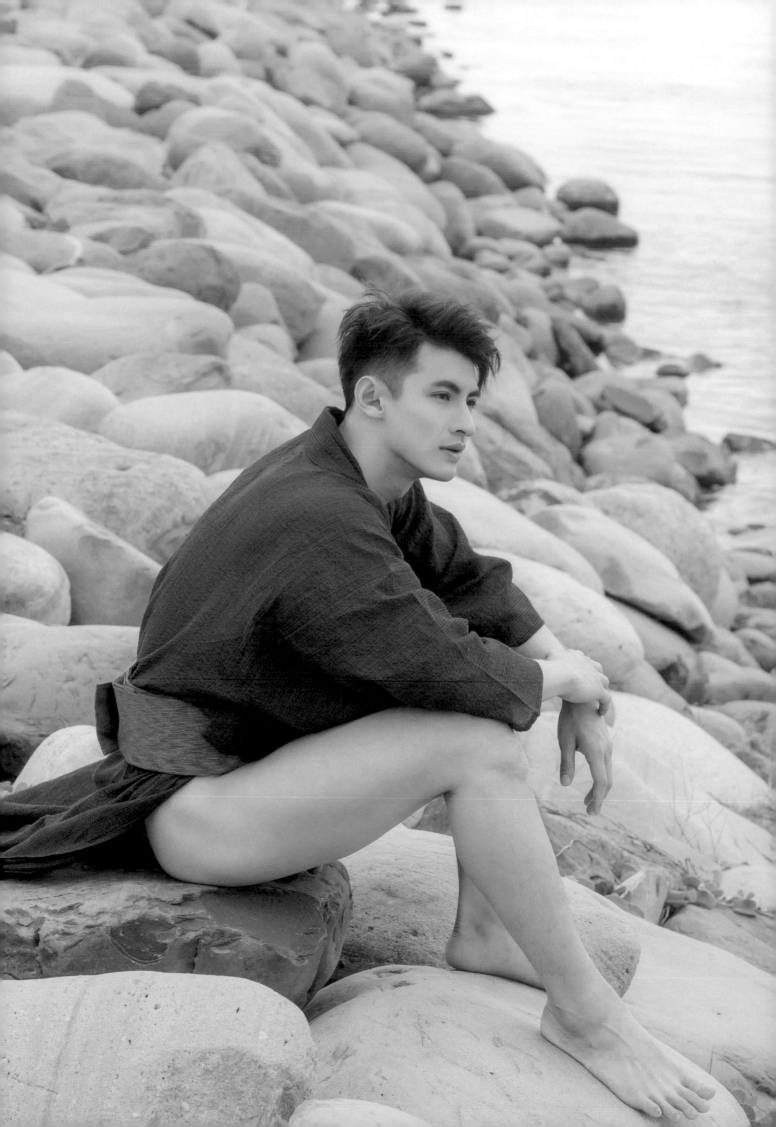

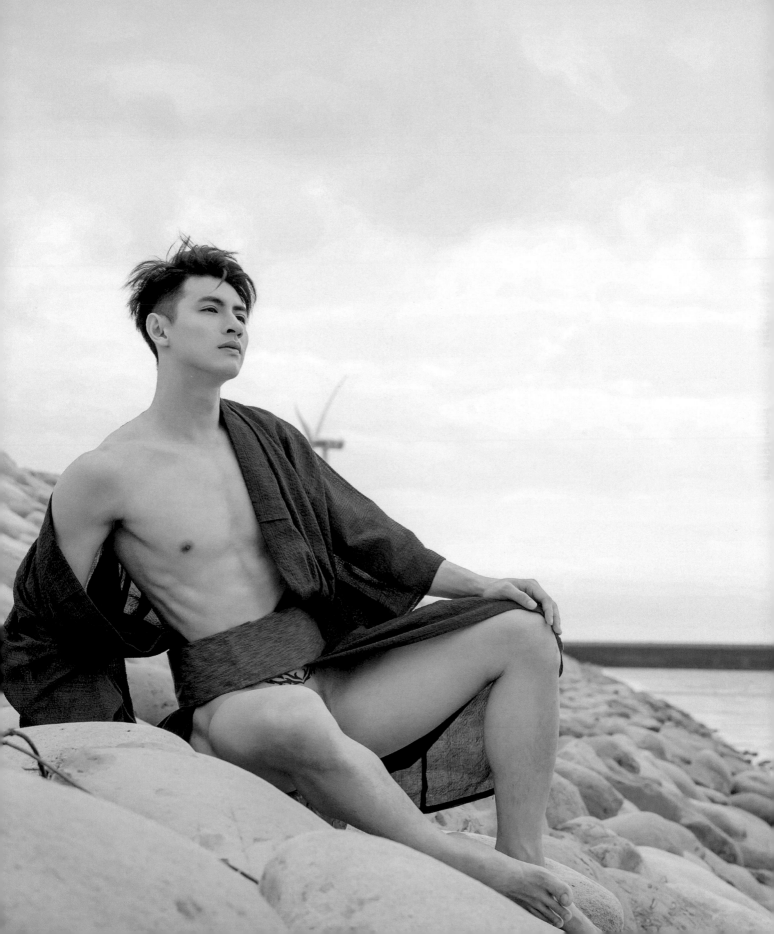

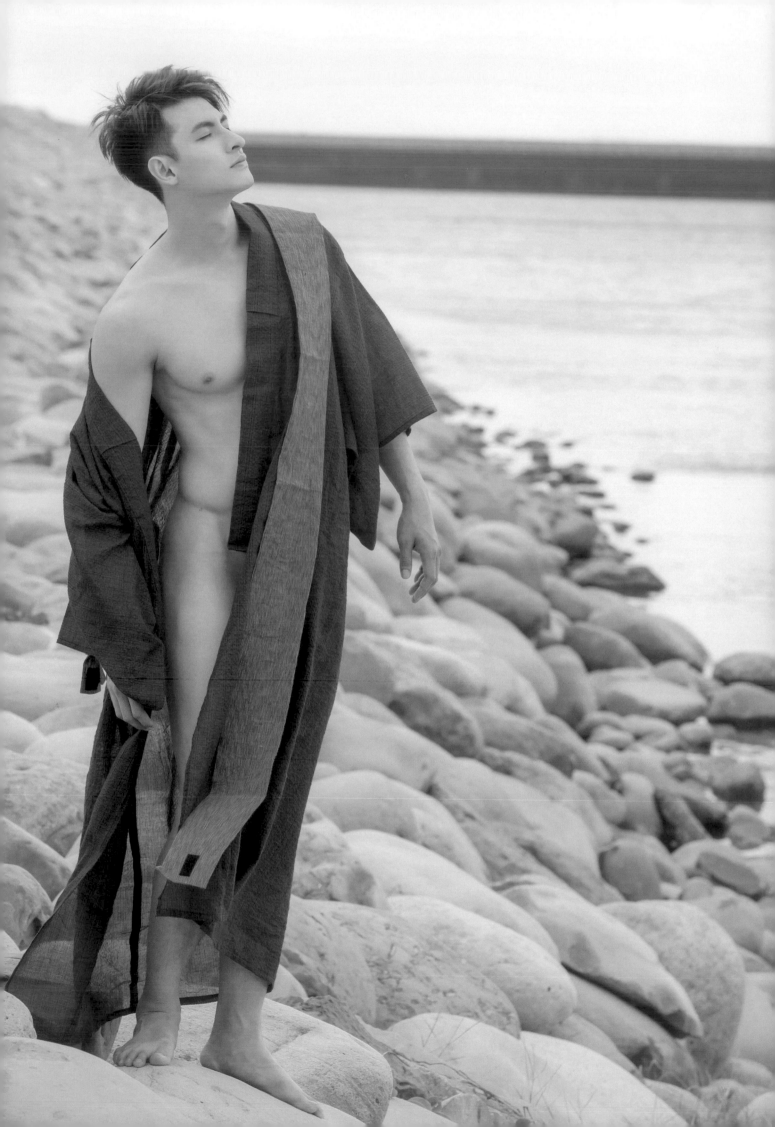

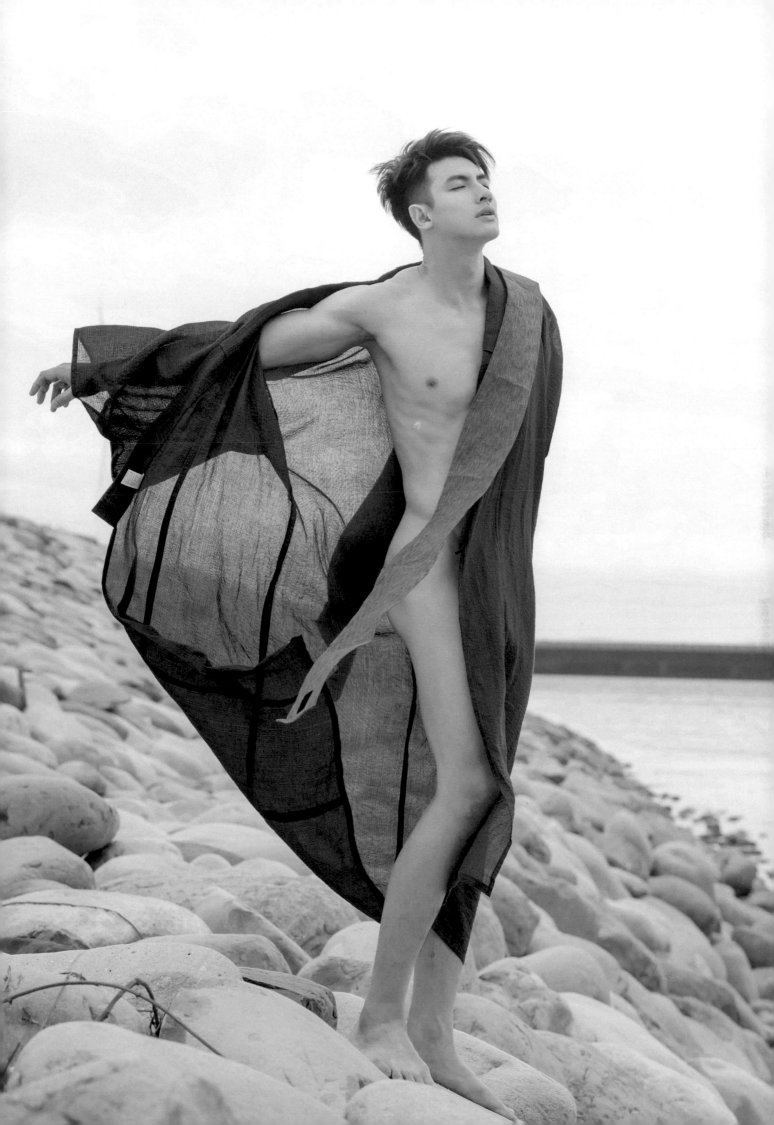

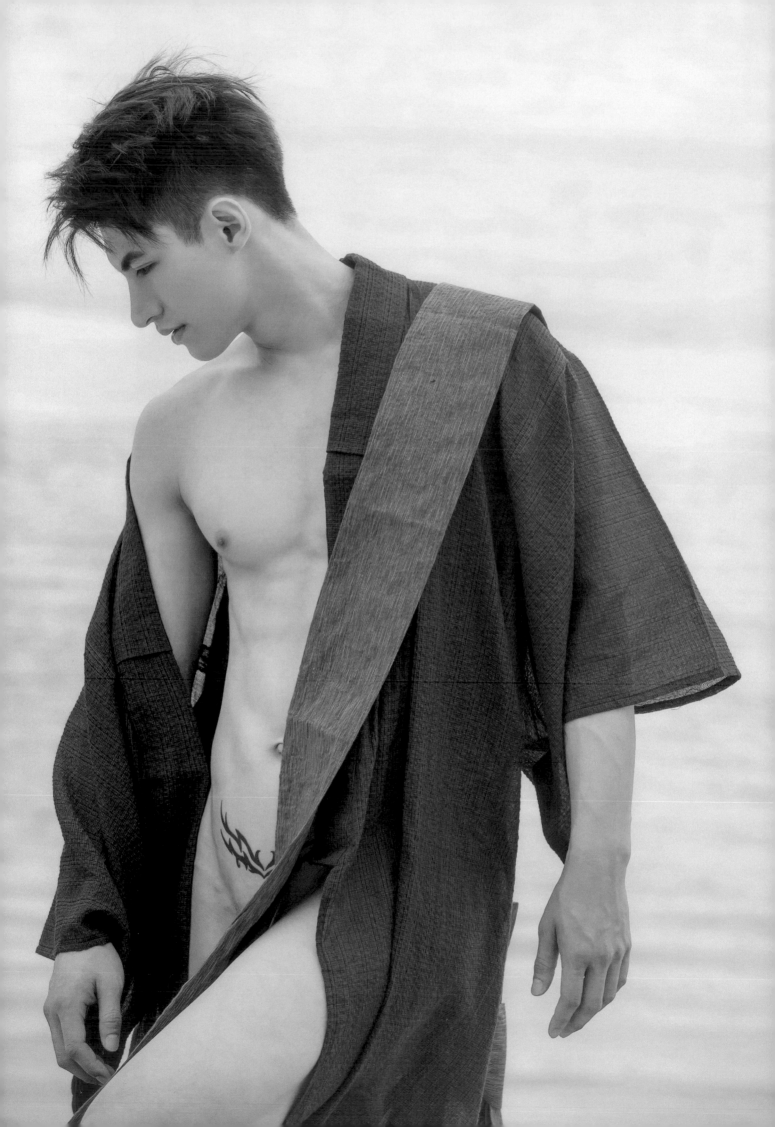

解開衣襟的束縛
裸身的秘密正悄悄 在我們之間展開

你
準備好了嗎？

>

TAKE THE SHACKLES OFF THE
CLOTHES

THE SECRET OF NAKEDNESS IS
QUIETLY BEING OPEND AMONG US.

ARE YOU READY?

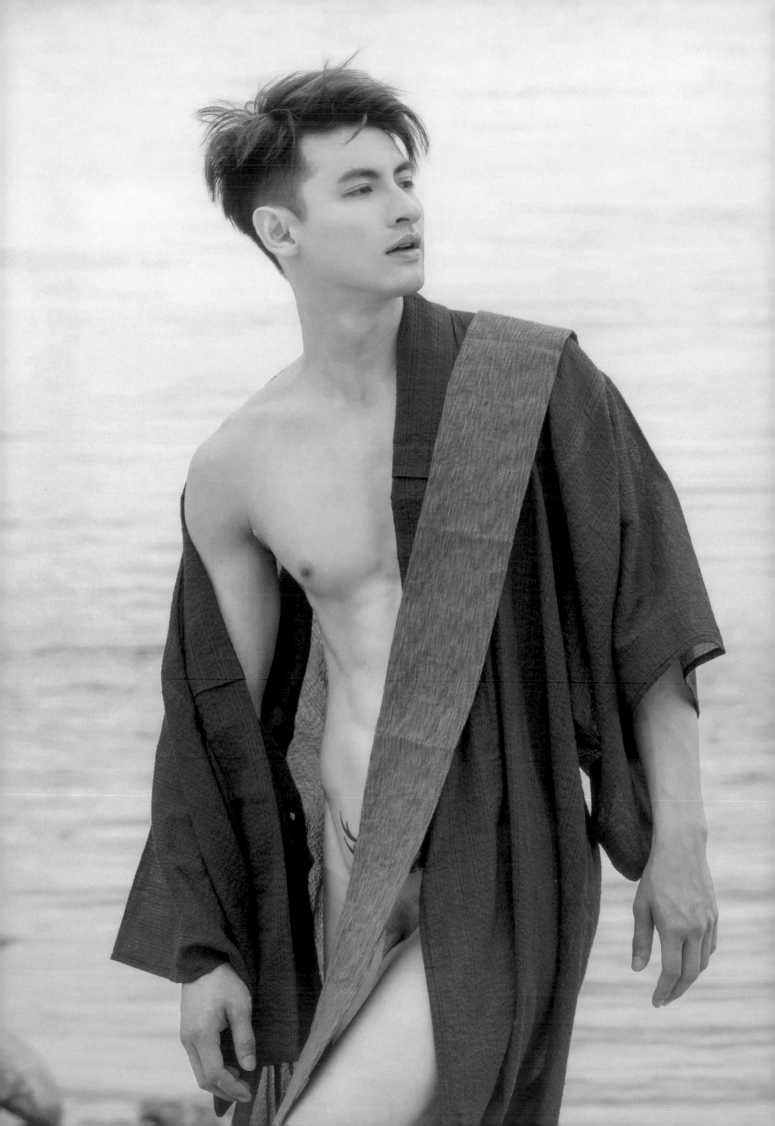

I THINK
MAYBE
YOU KNOW

MY
HEART

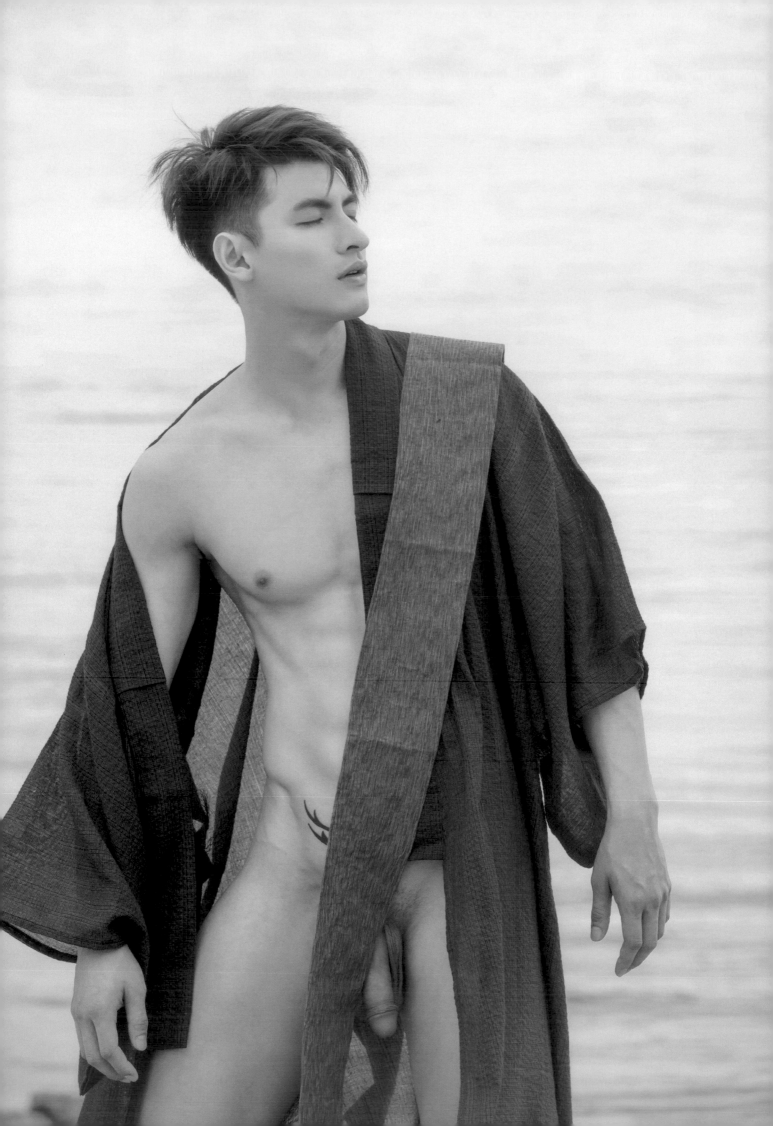

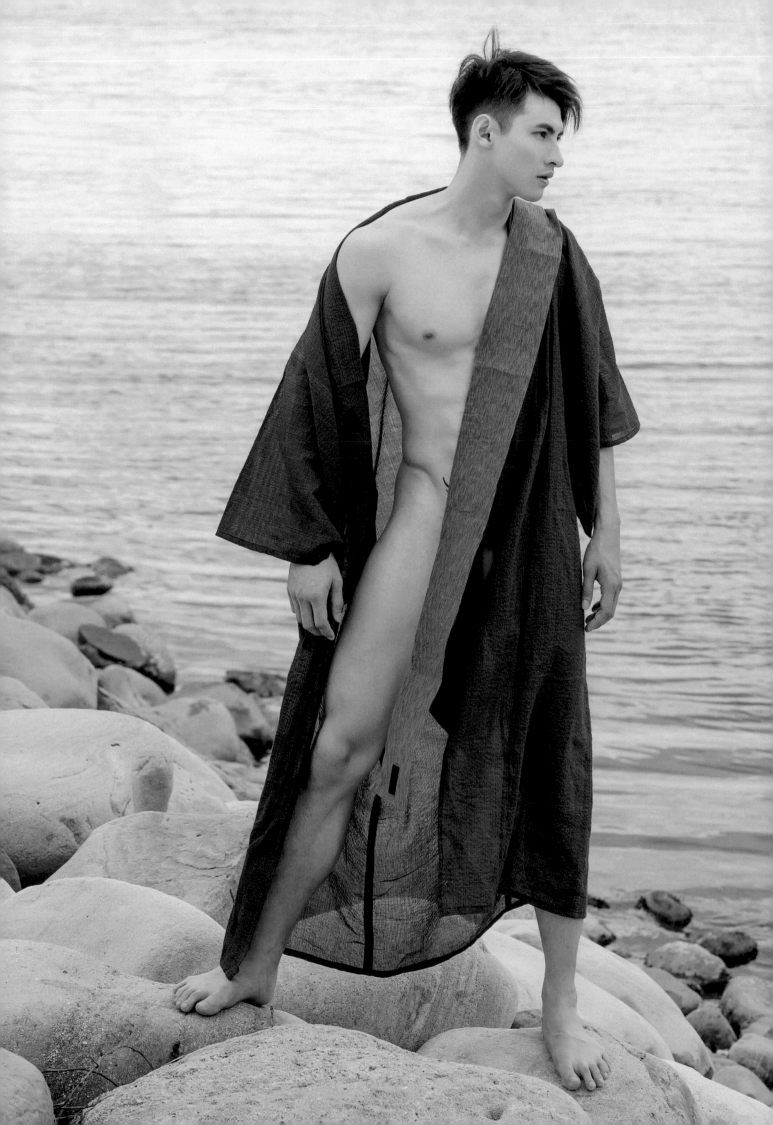

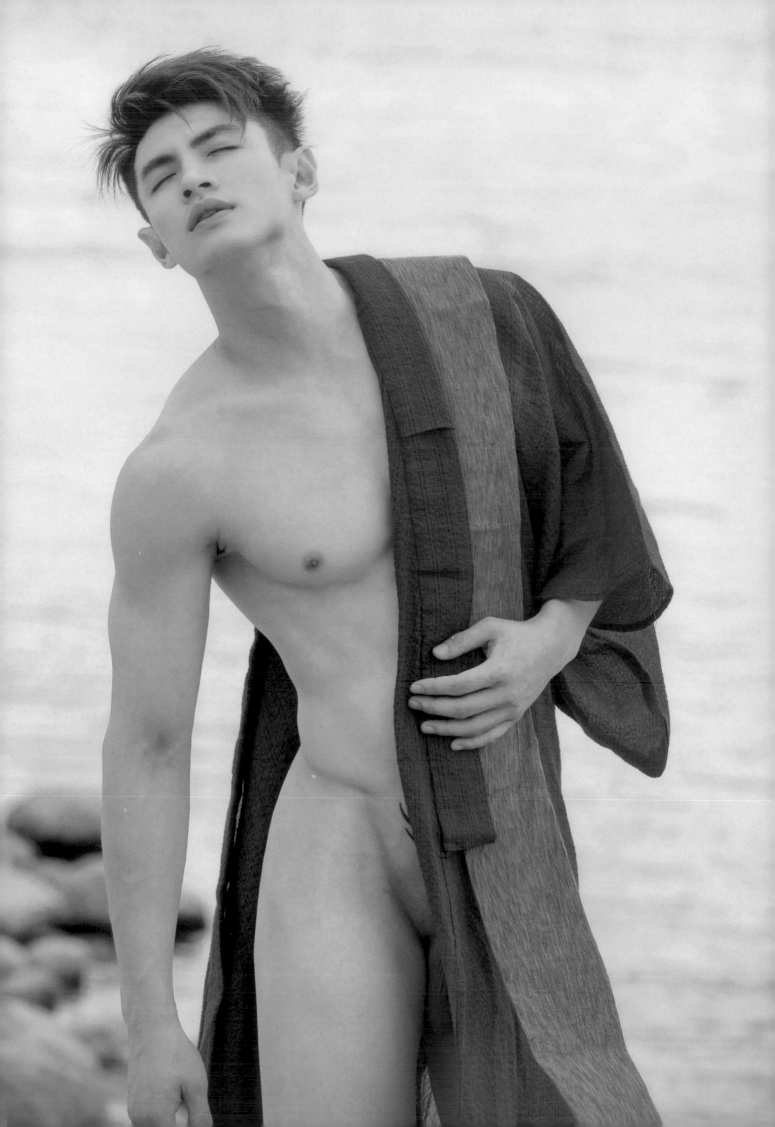

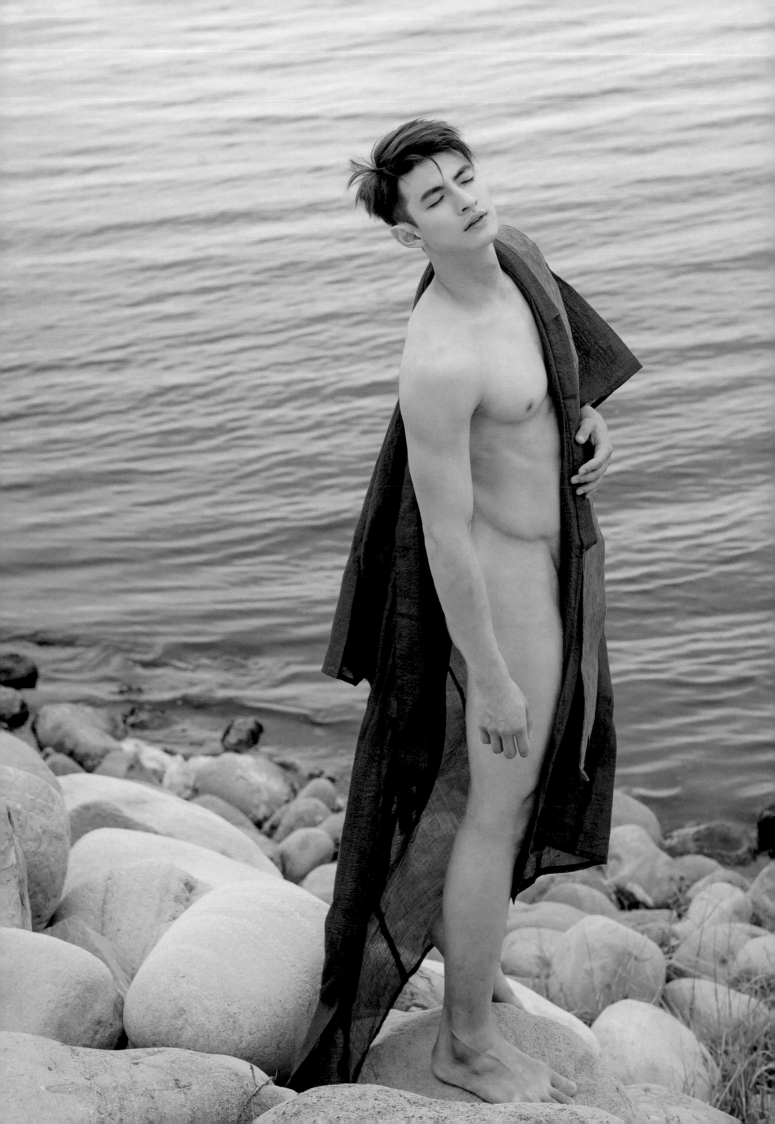

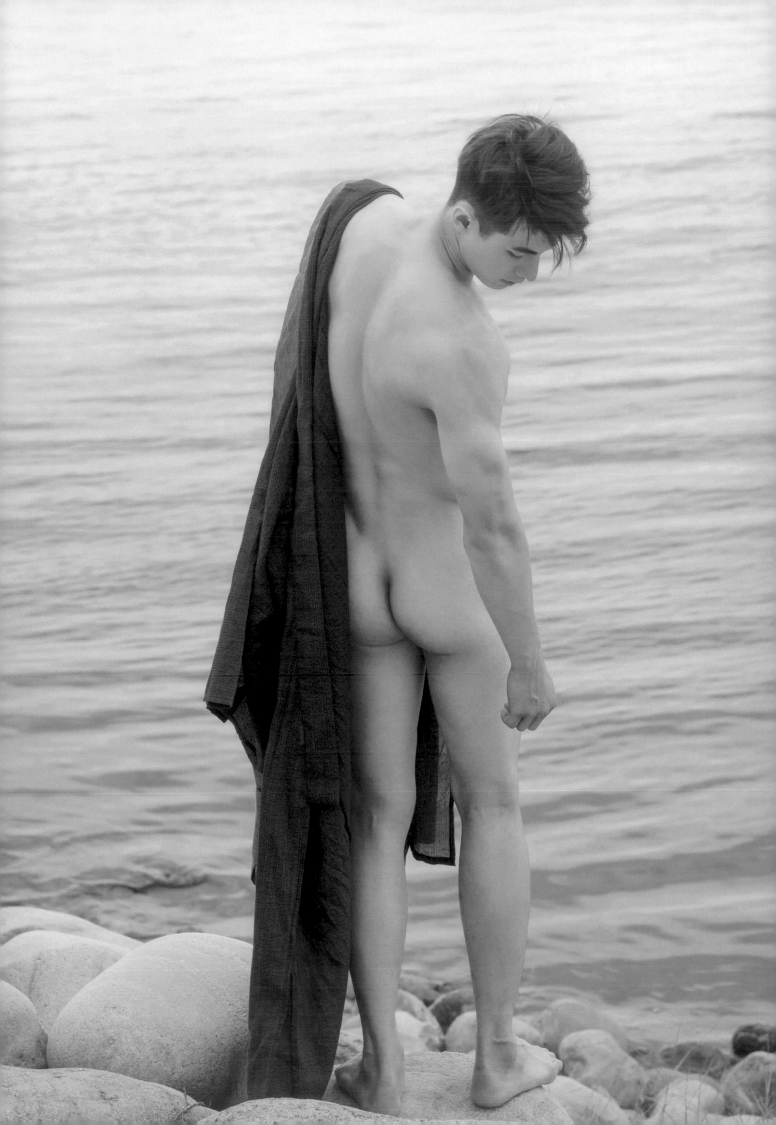

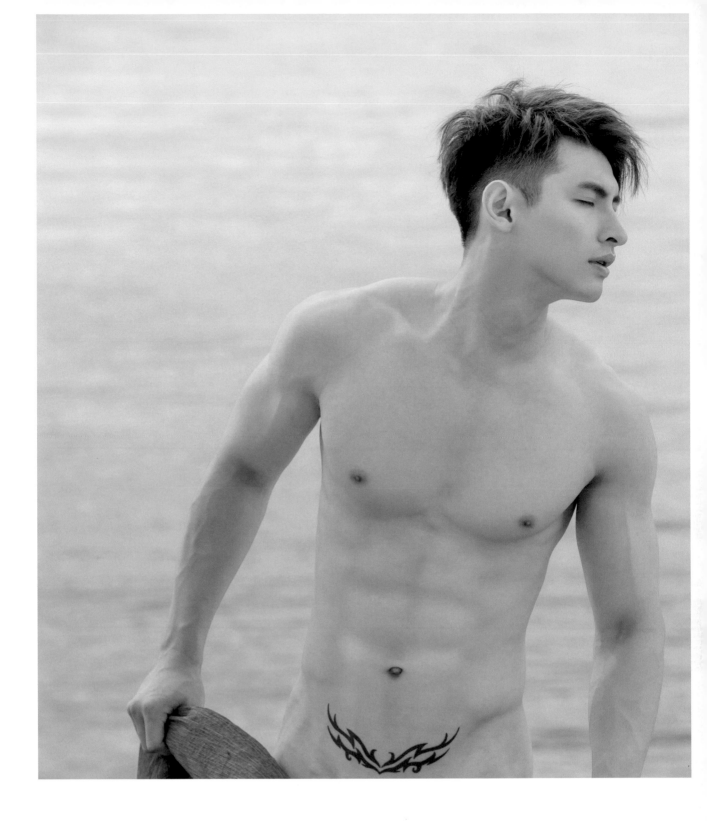

WANT

TO

KEEP

CATCHING

YOUR

EYES

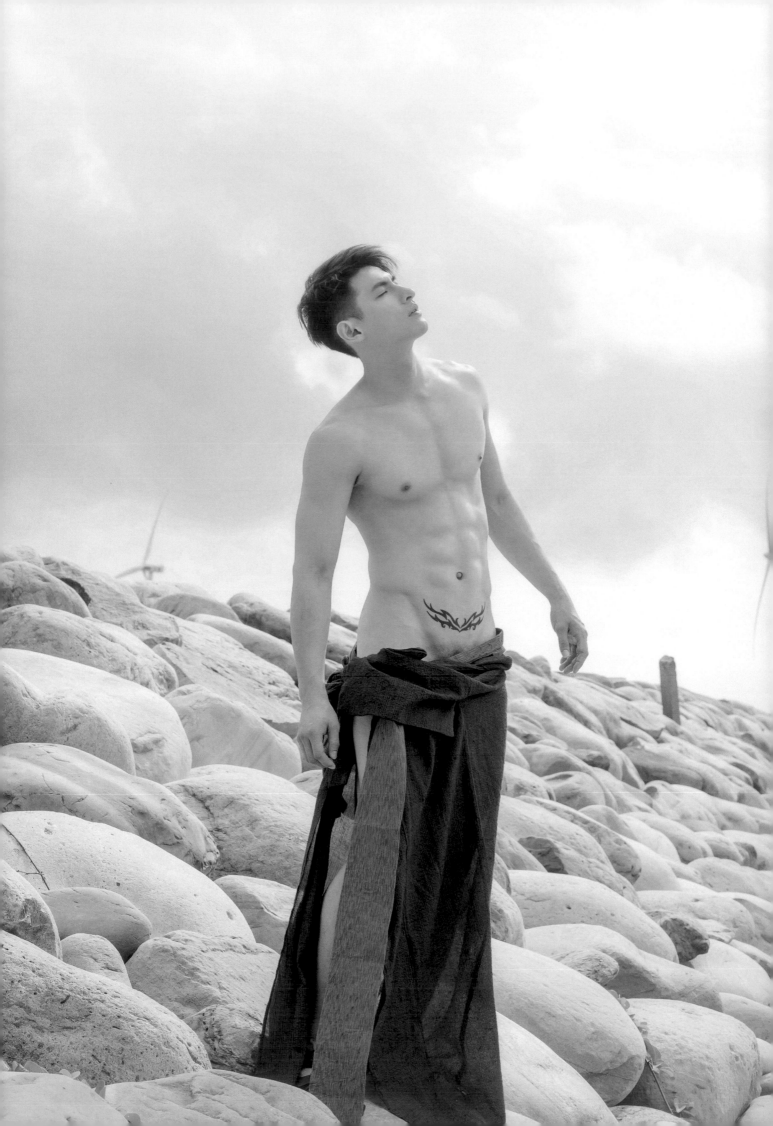

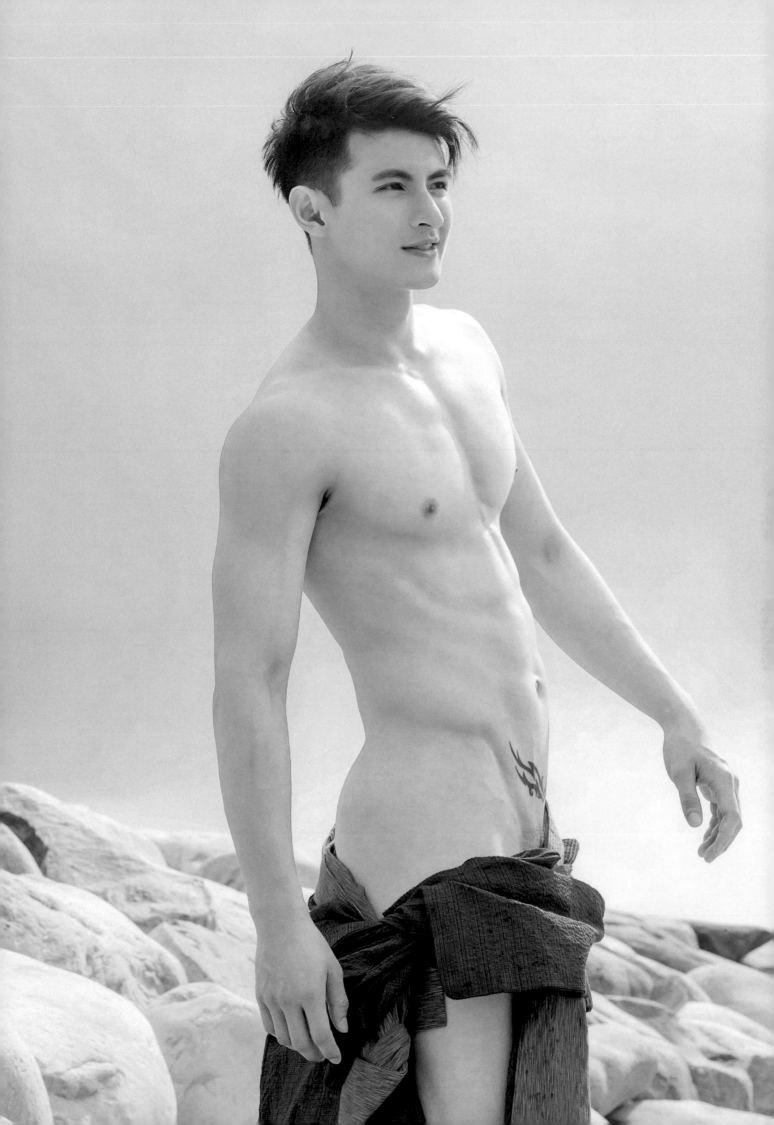

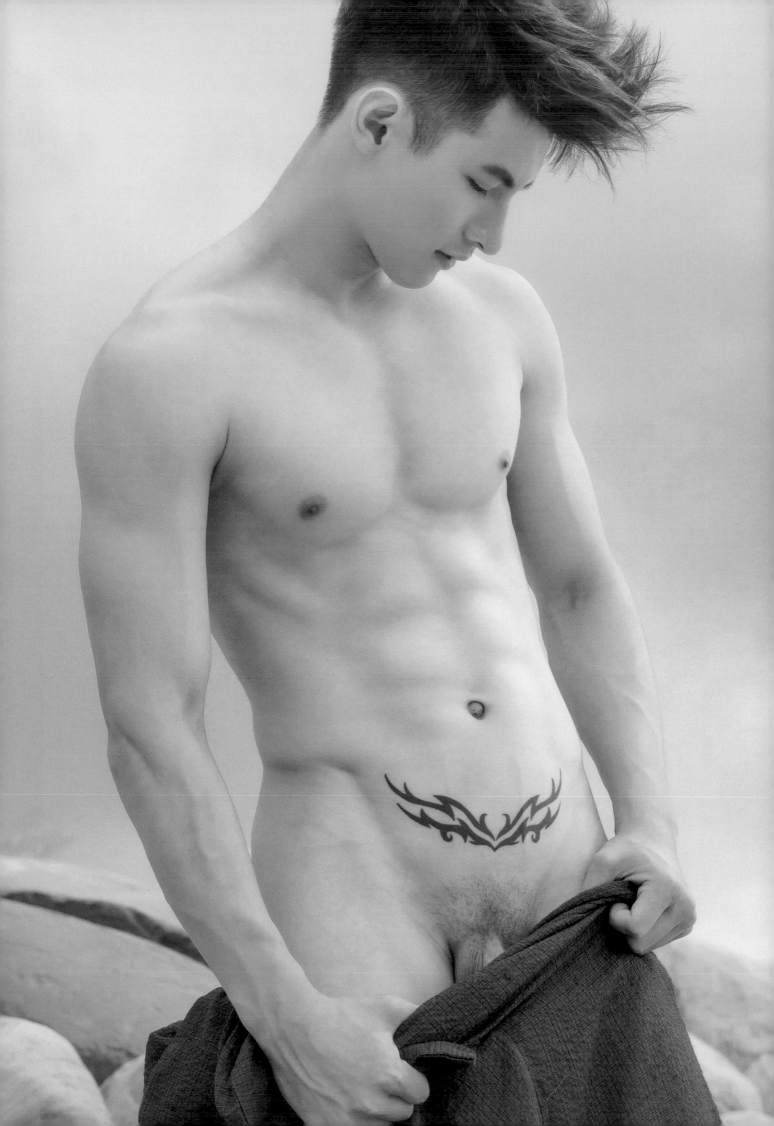

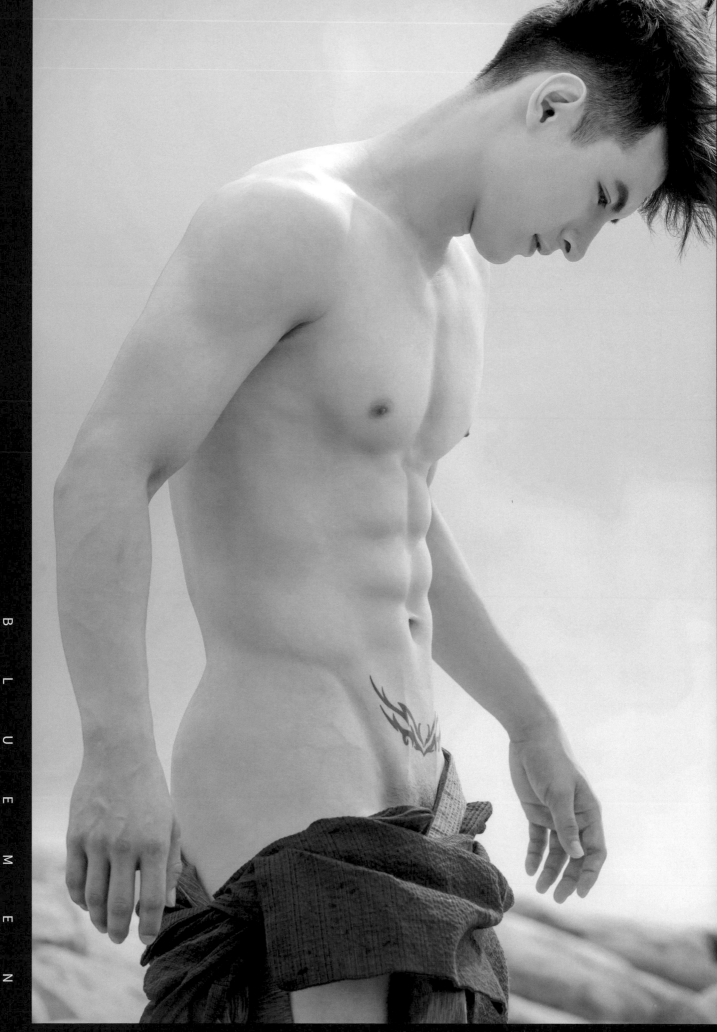

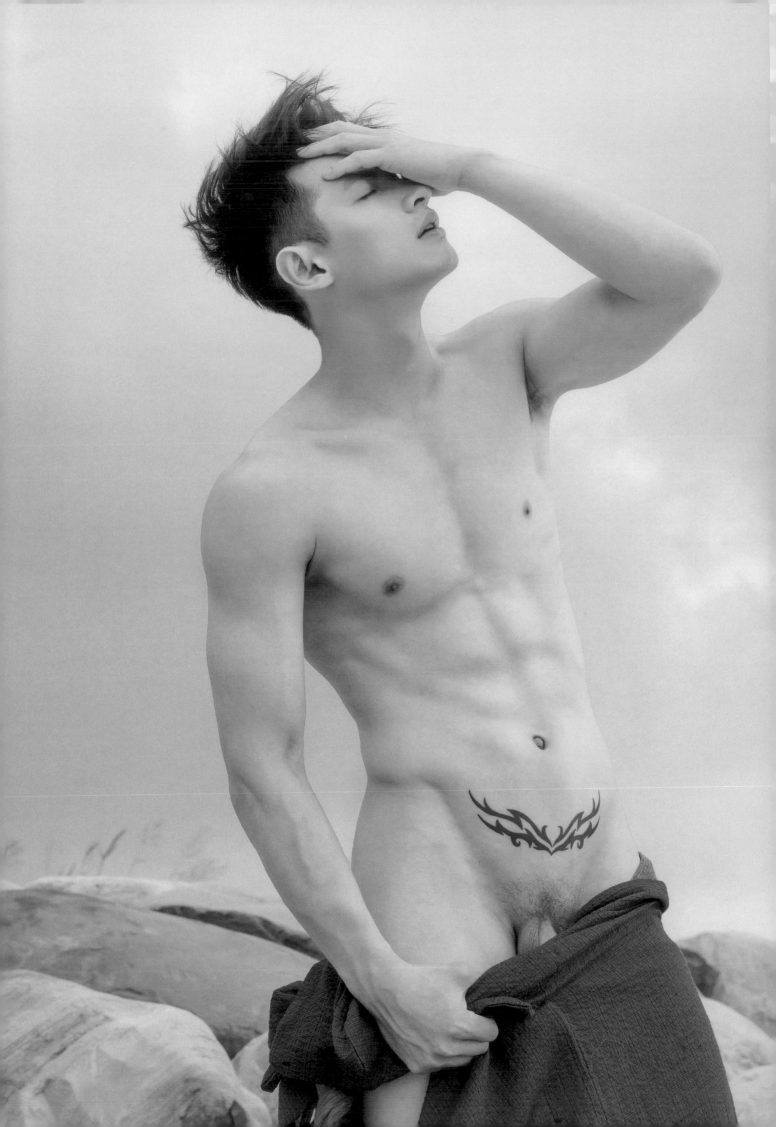

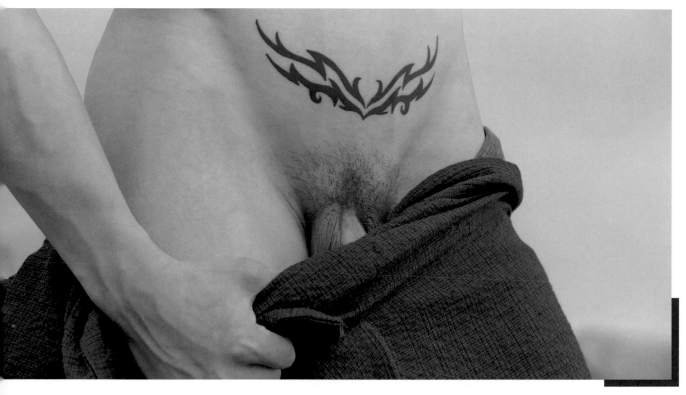

B L U E M E N

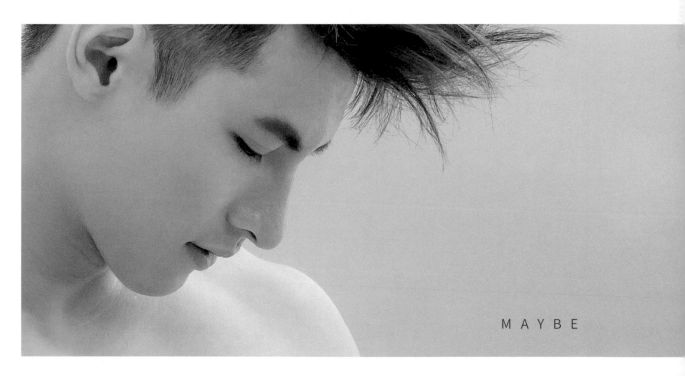

MAYBE

I KNOW

YOUR

HEART

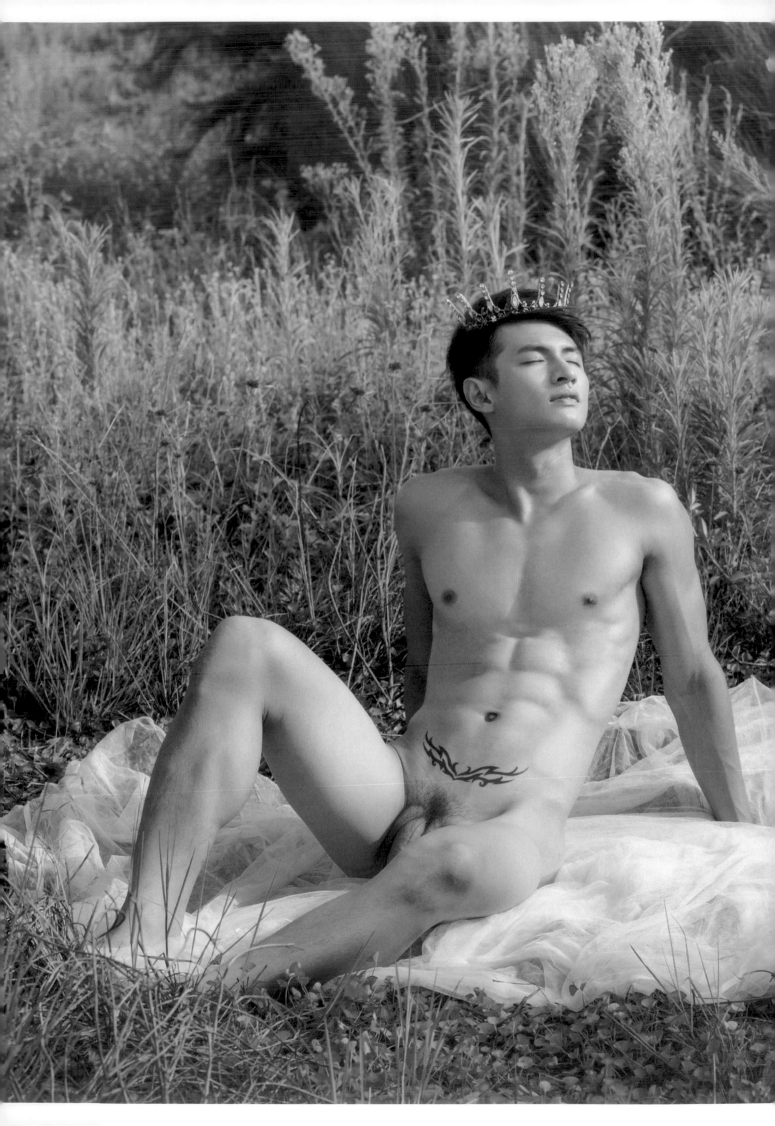

BLUE MEN

NO. 14

穆 星

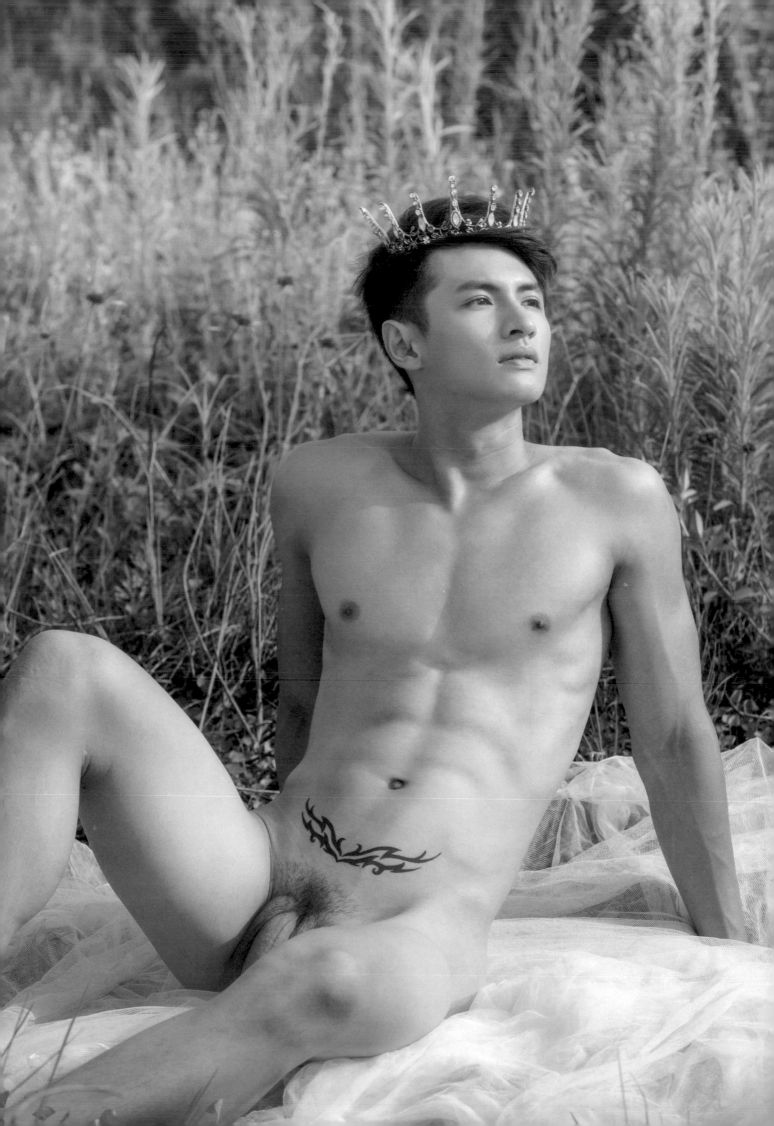

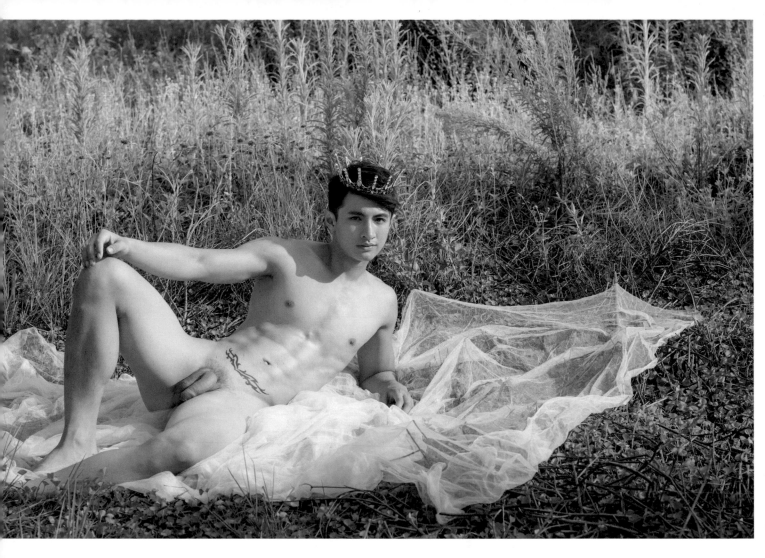
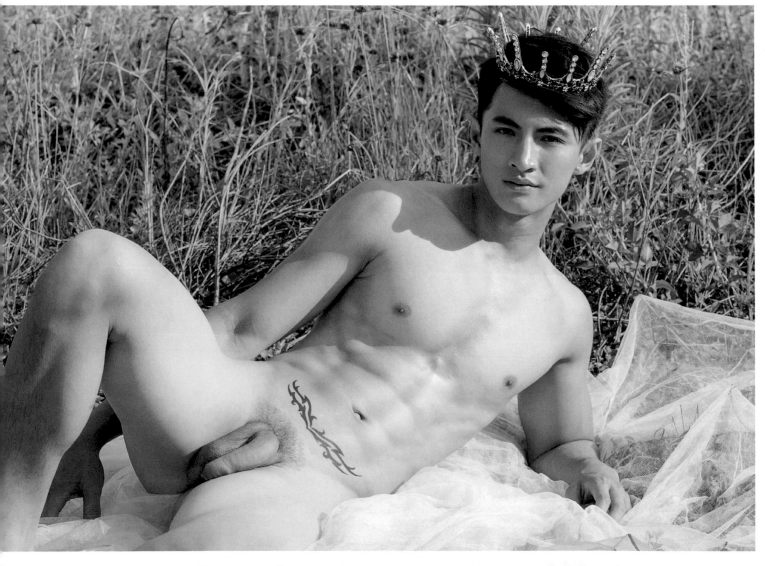

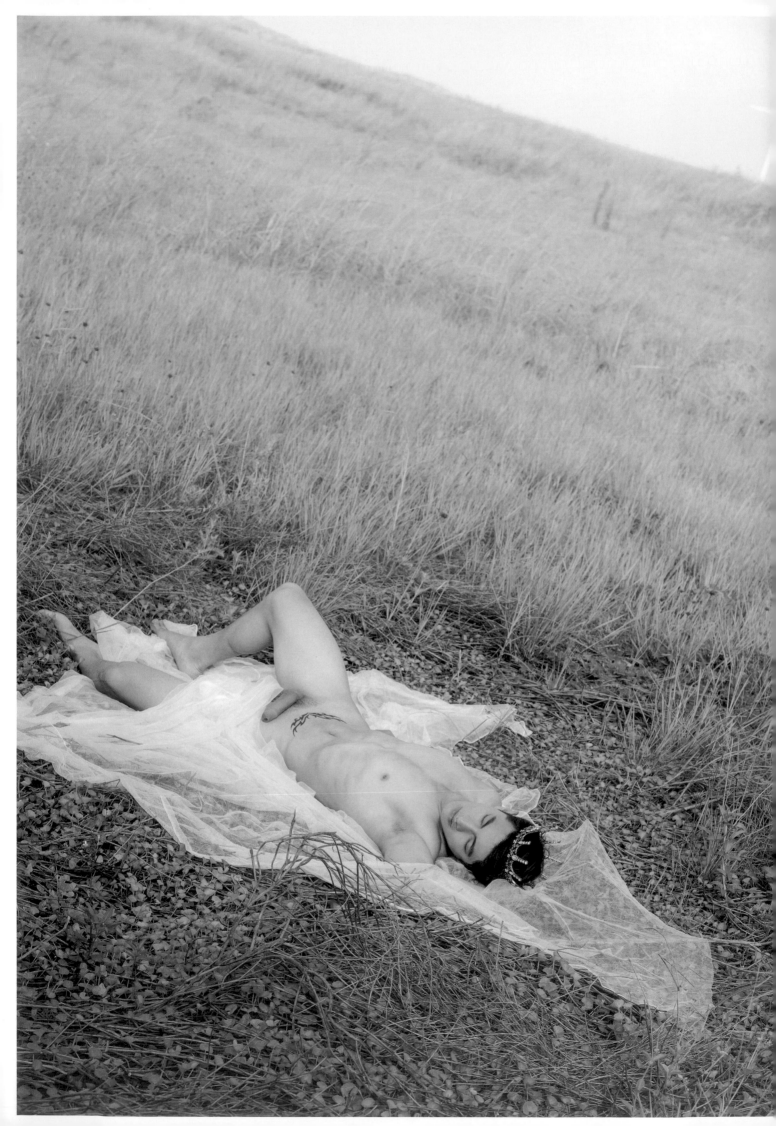

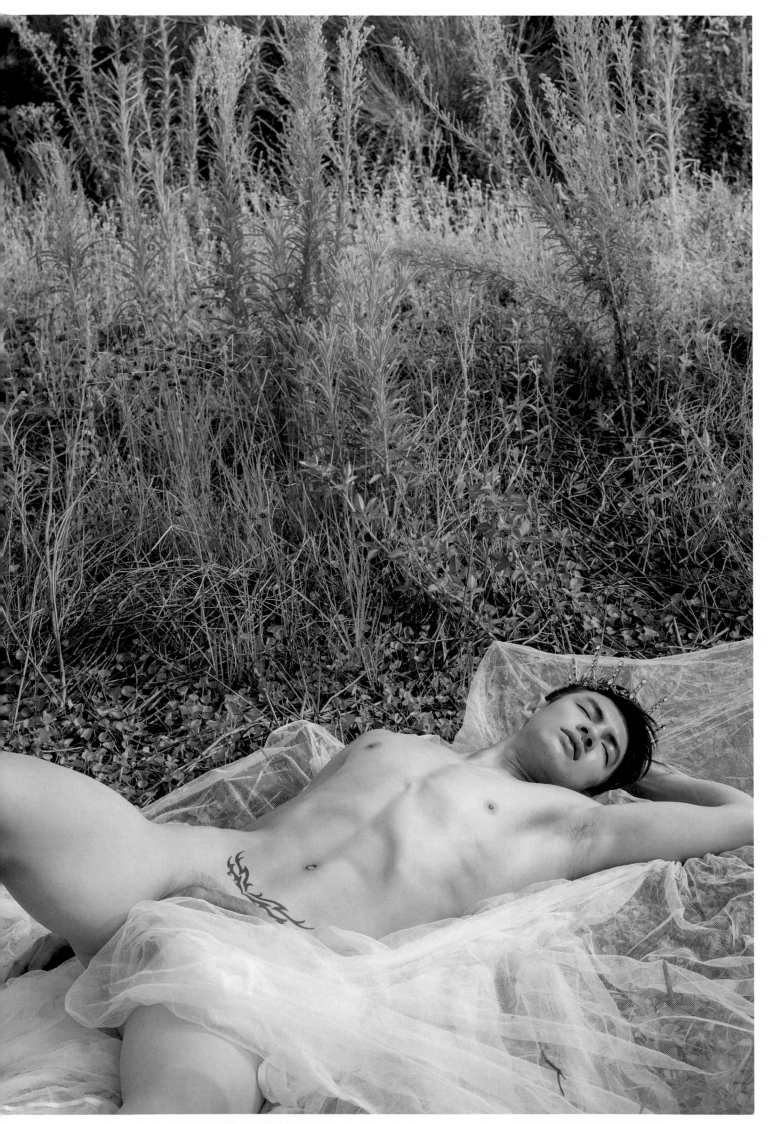

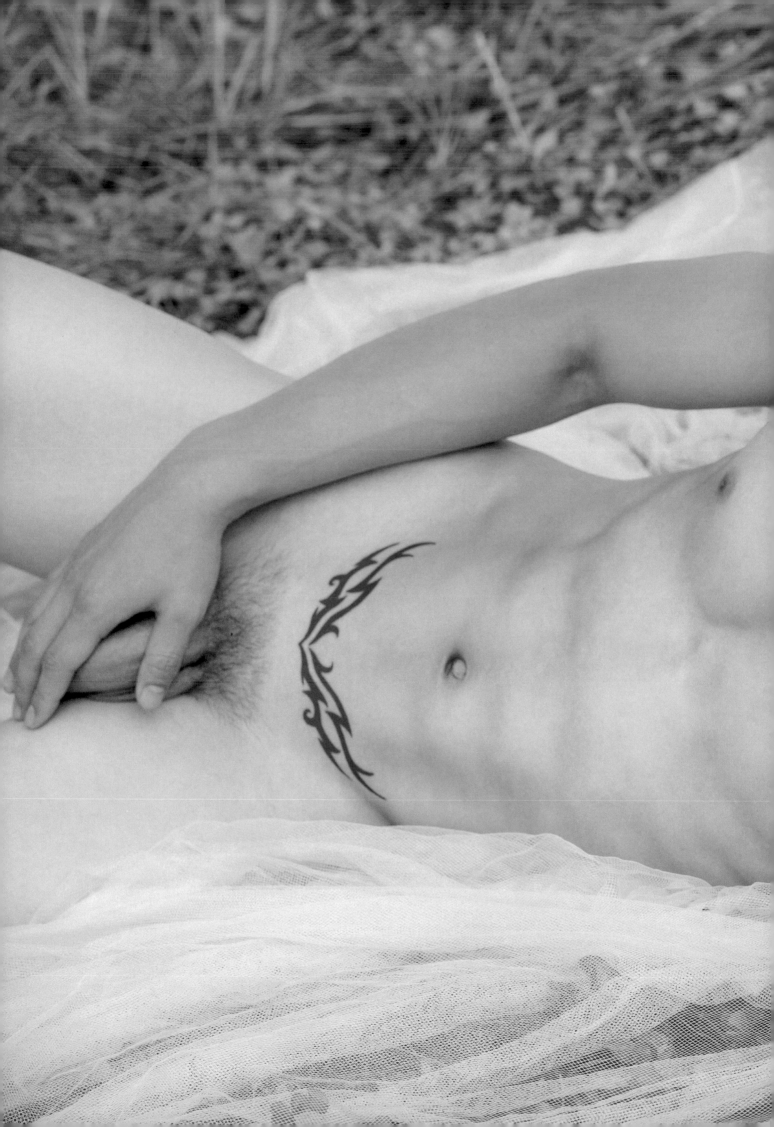

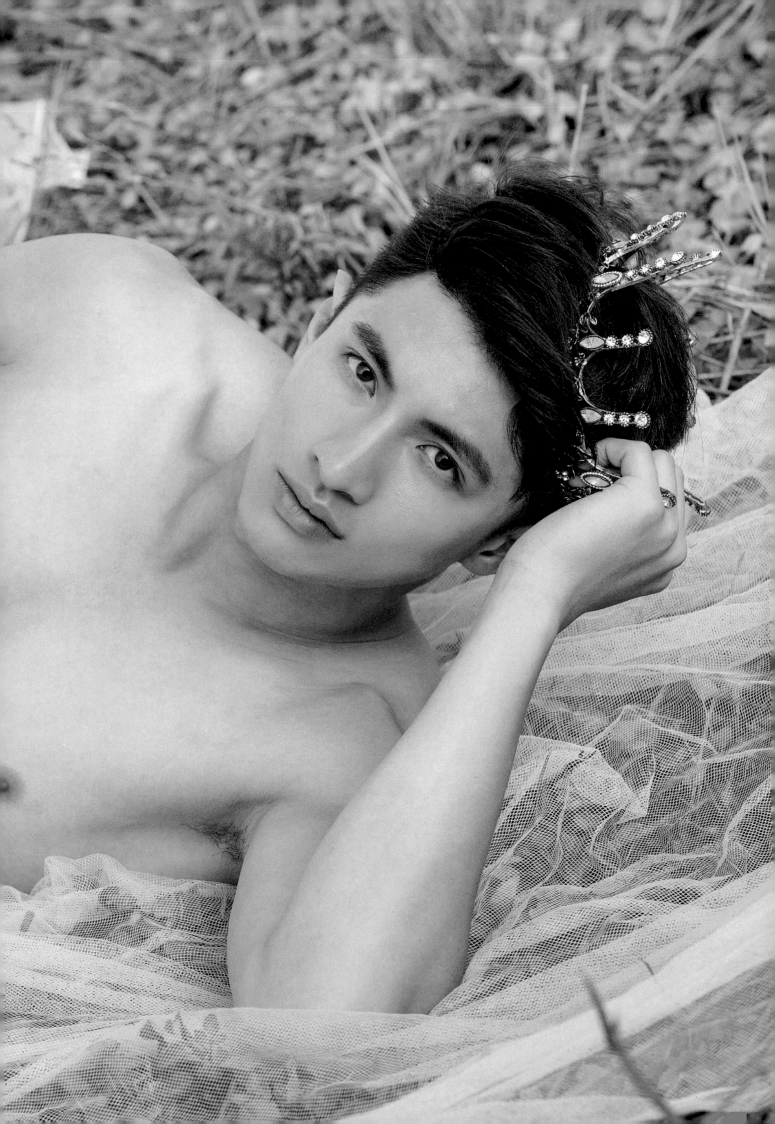

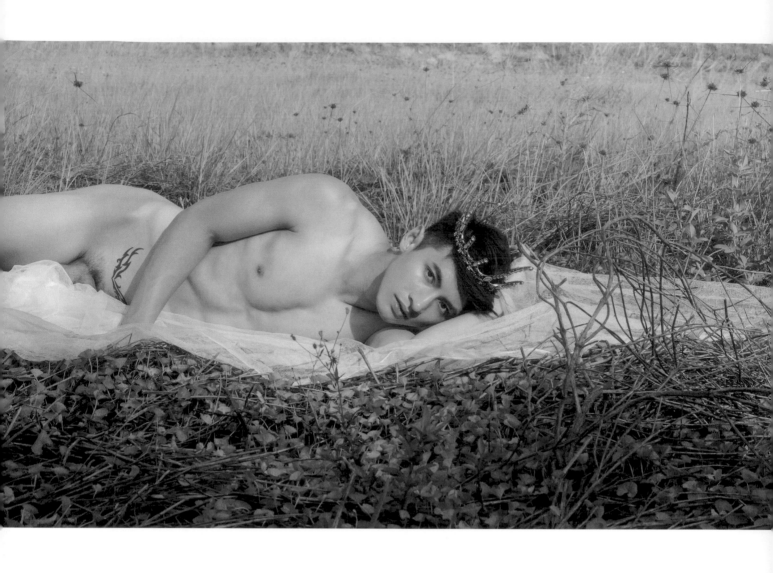

躺 在 地 面 上 被 草 堆 捧 著

像 是 躺 在 你 的 懷 裡

被 你 細 心 保 護 著 的 感 覺

喜 歡 這 樣

靜 靜 看 著 躺 在 我 身 邊 的 你

LYING ON THE

GROUND

JUST LIKE LYING

IN YOUR ARMS

AND

THE FEELING

THAT YOU CARE ABOUT ME

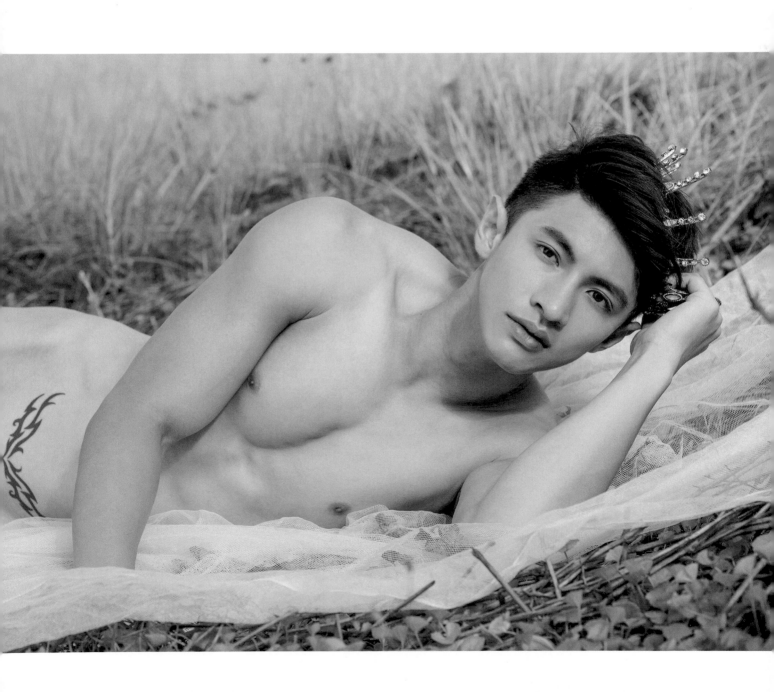

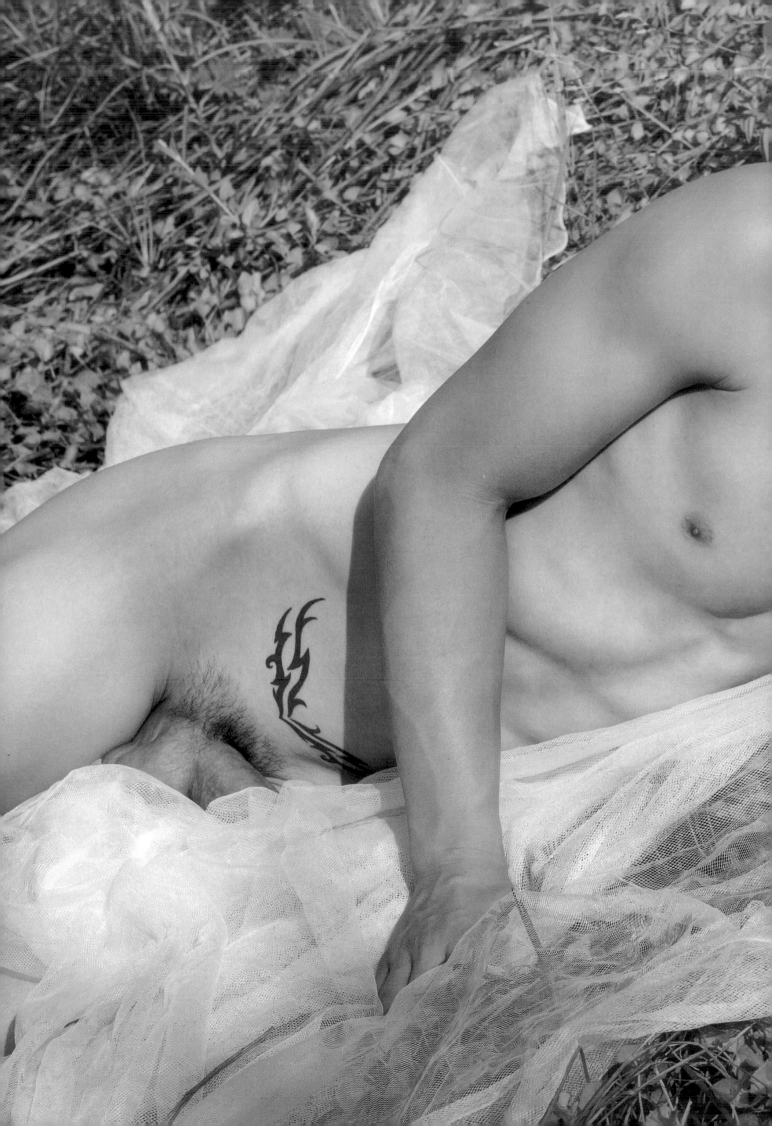

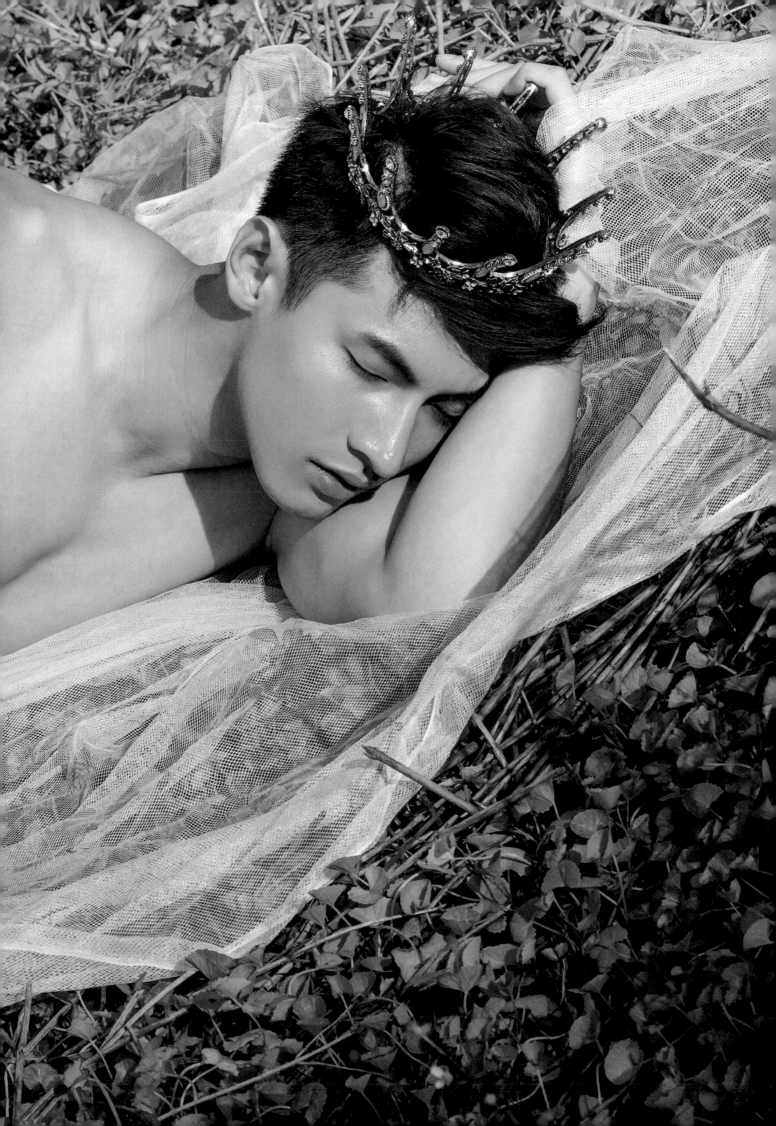

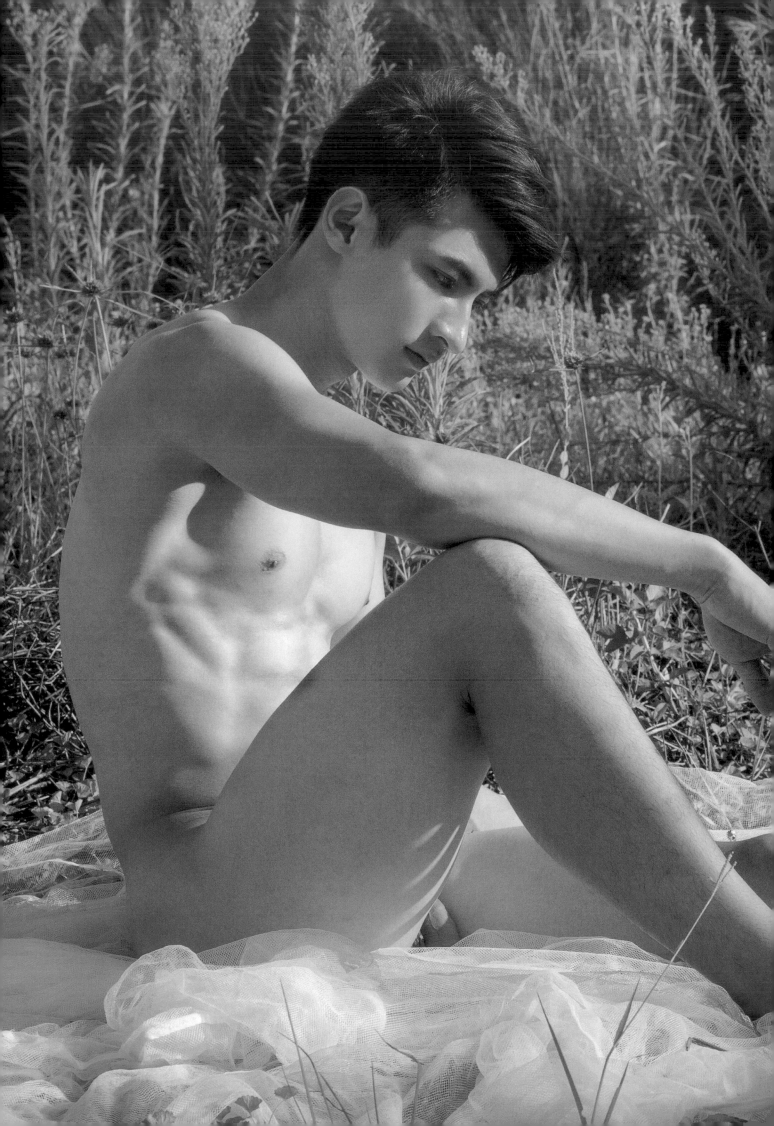

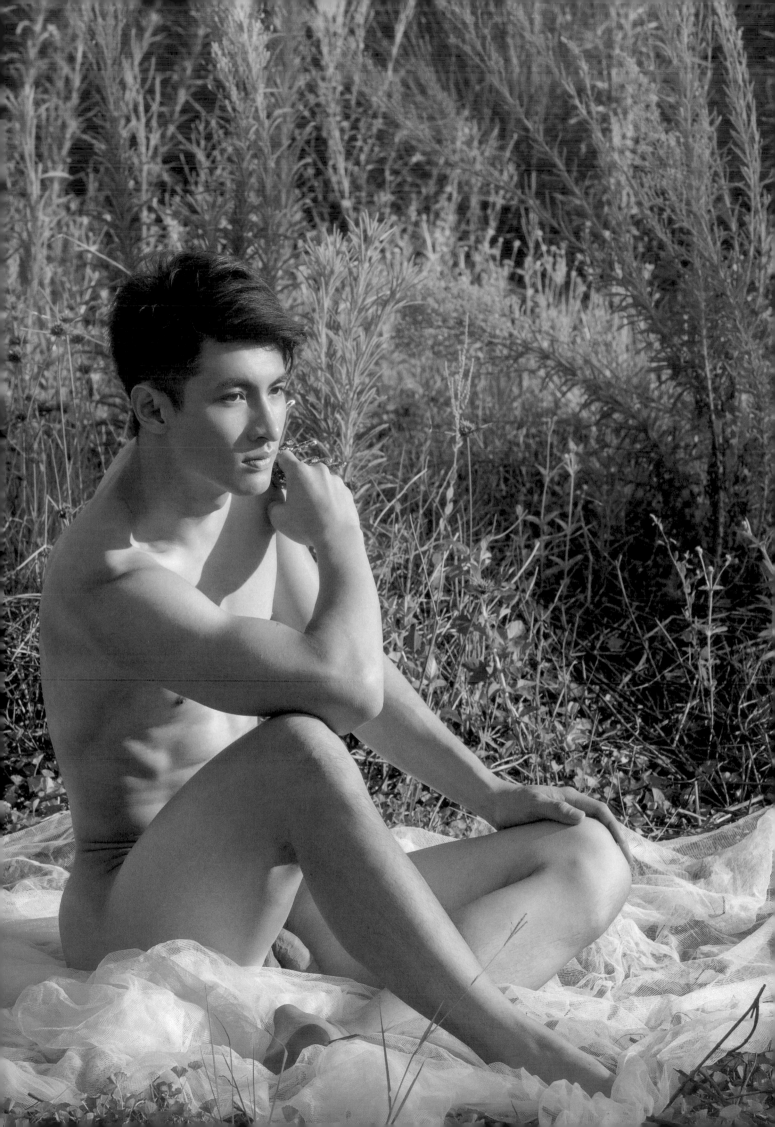

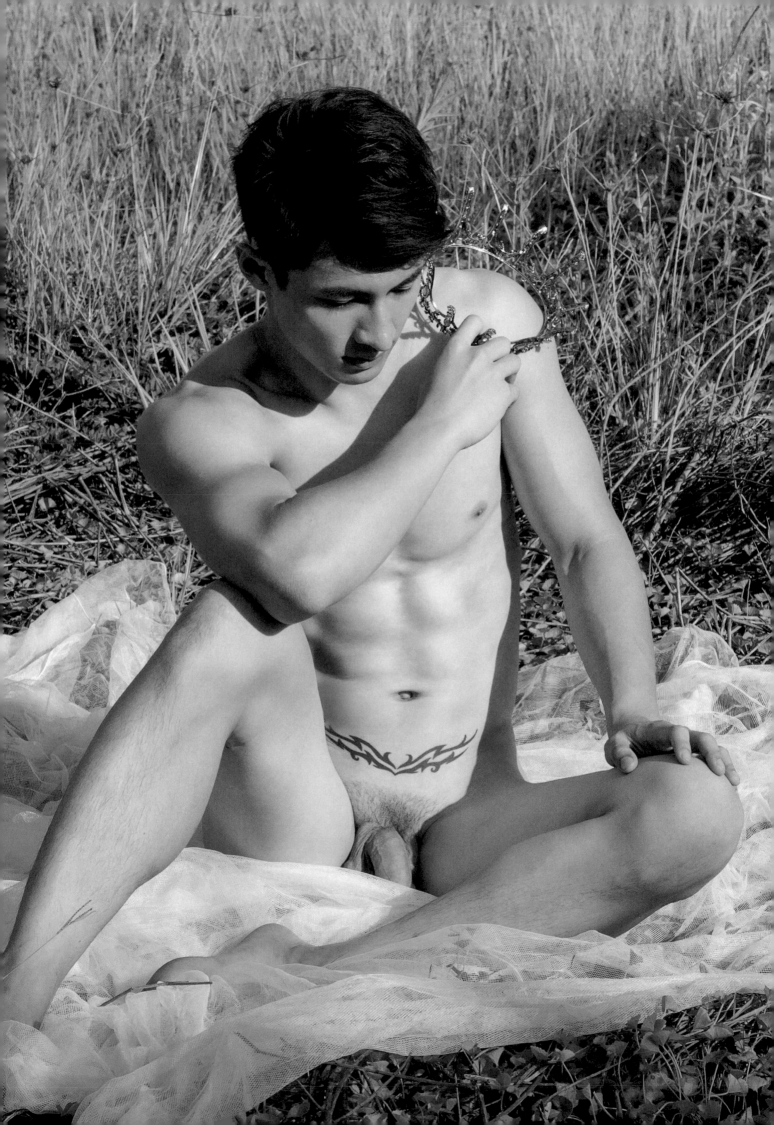

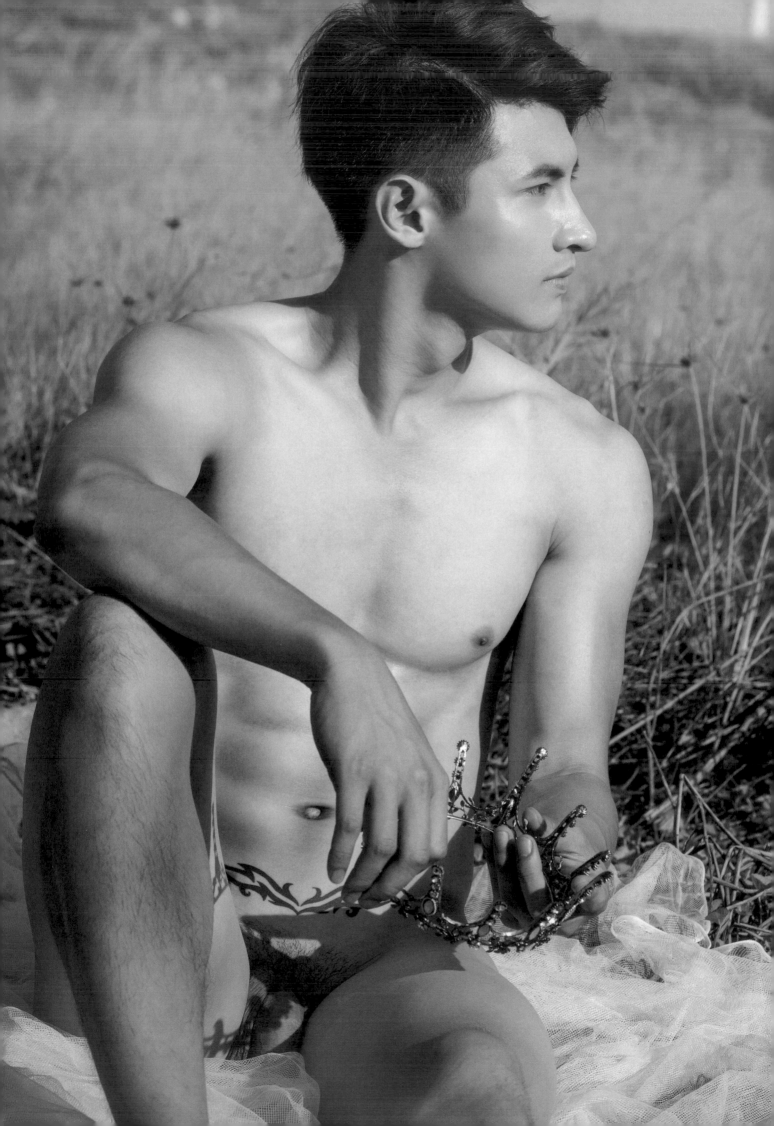

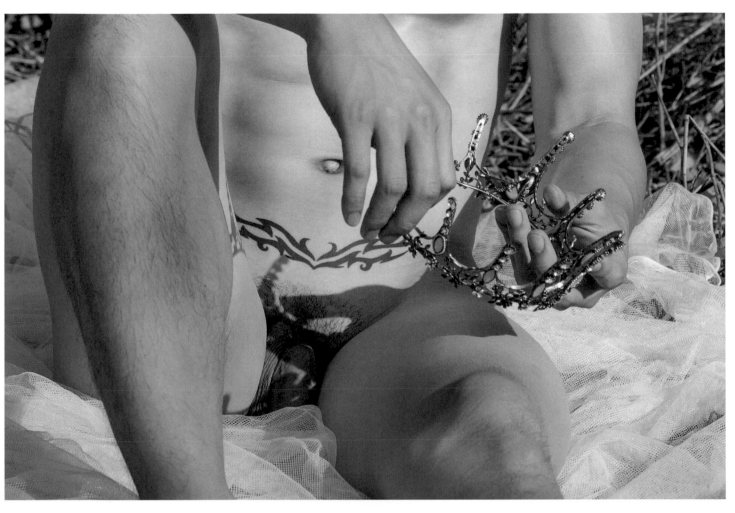
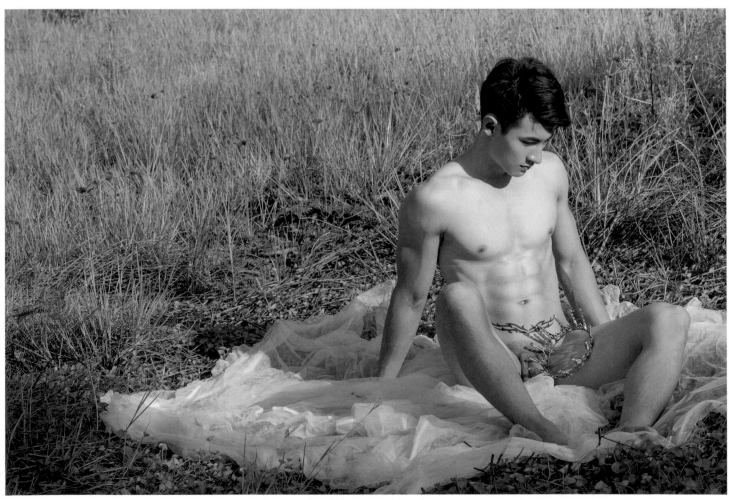

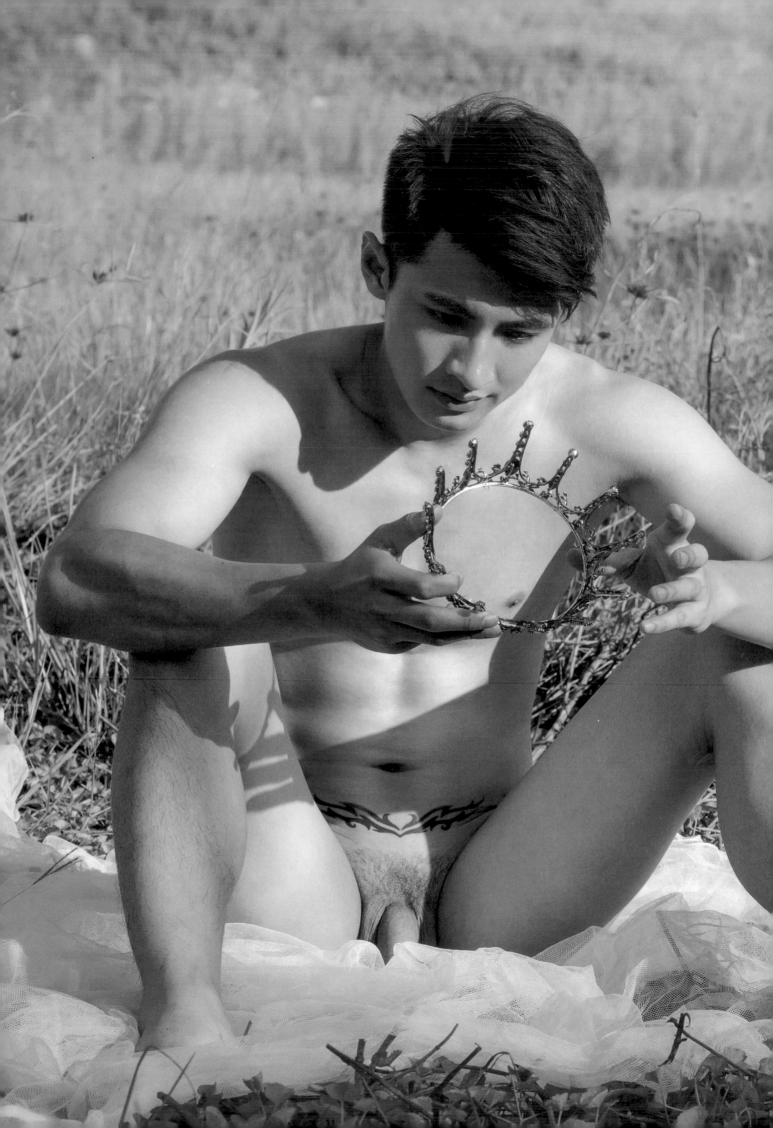

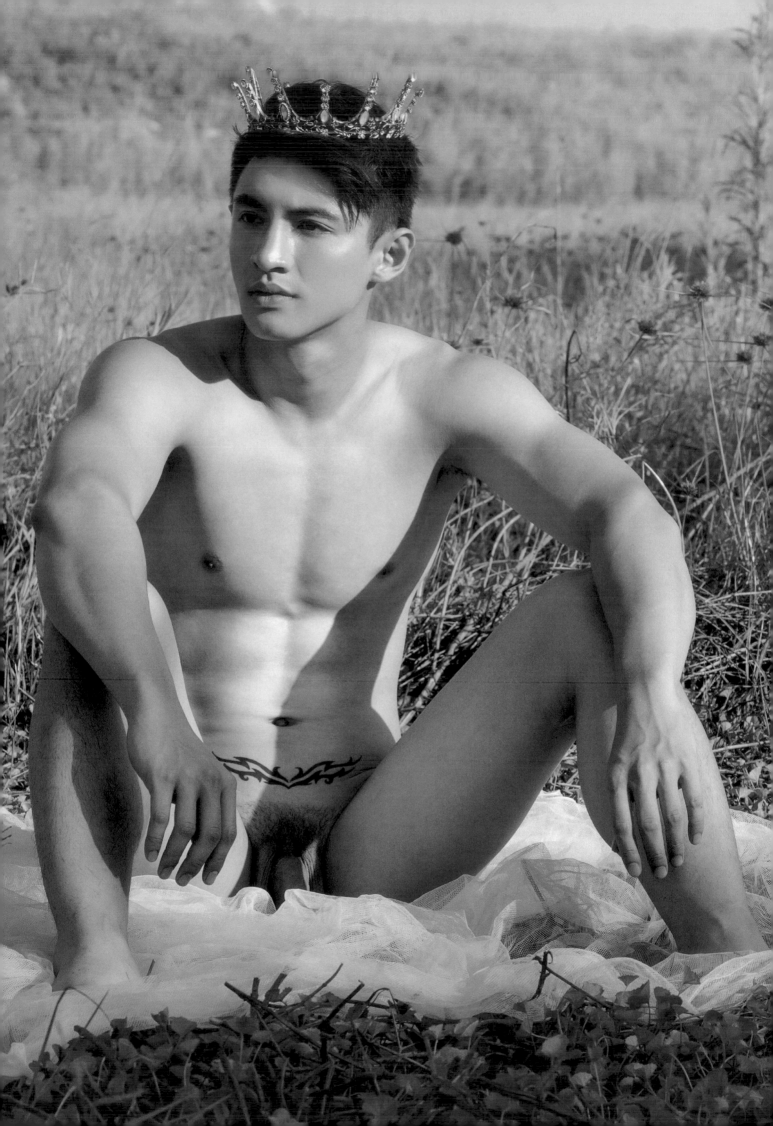

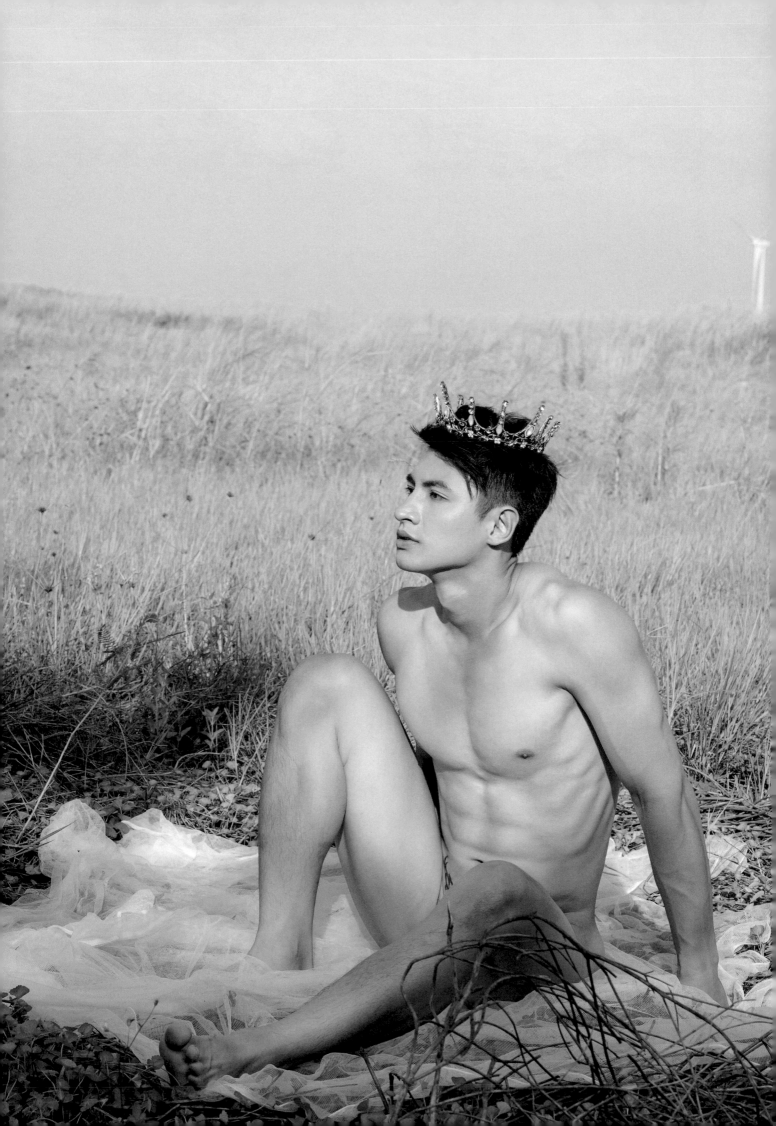

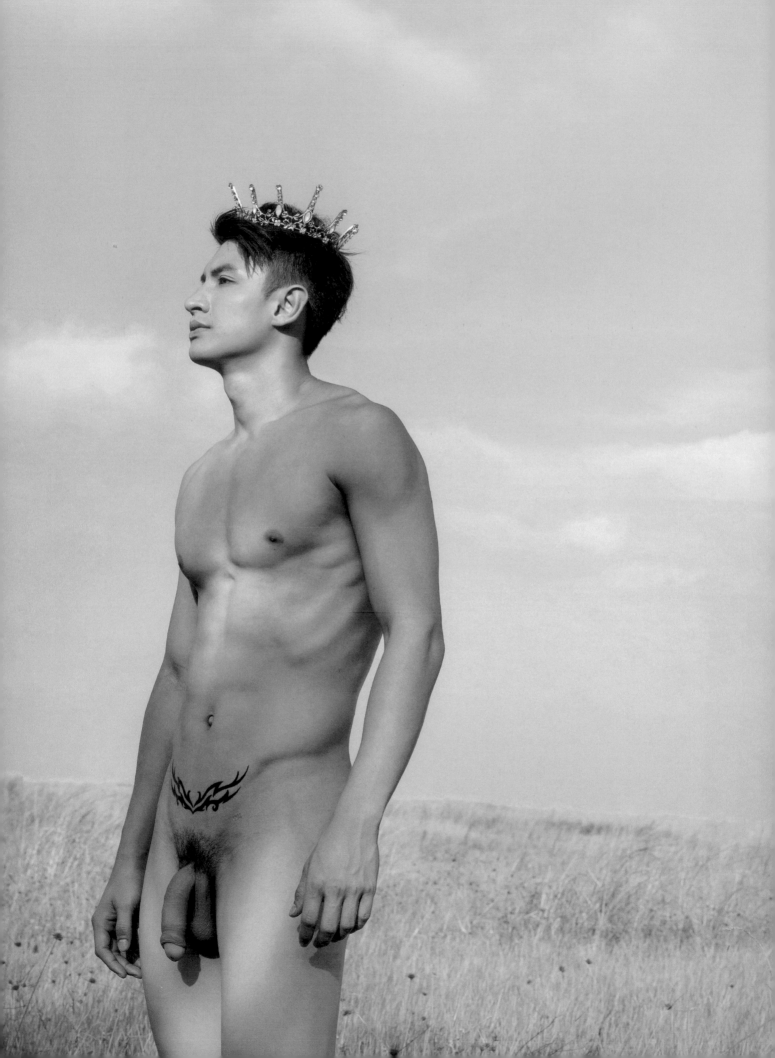

CONQUER

YOUR

HEART

戴上皇冠就好像征服了這草原上的一切

那你征服的了我嗎？

" Wearing the crown is like conquering everything on the grass."

"Then can you conquer me ?"

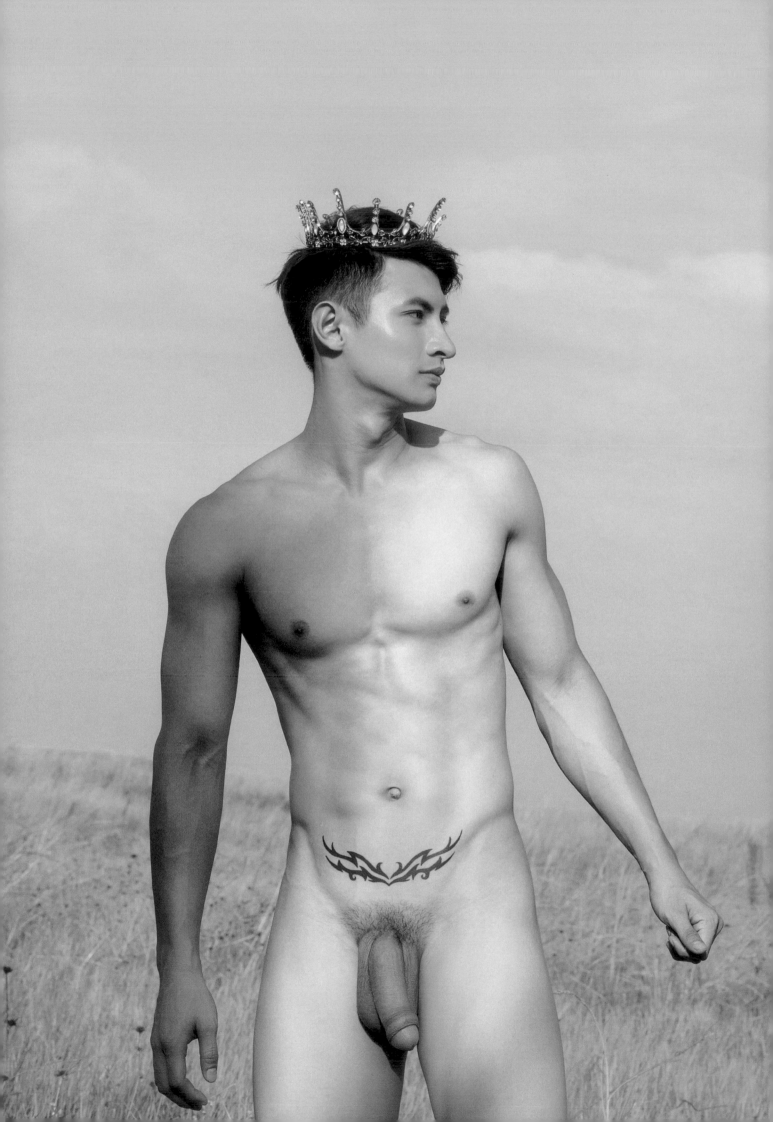

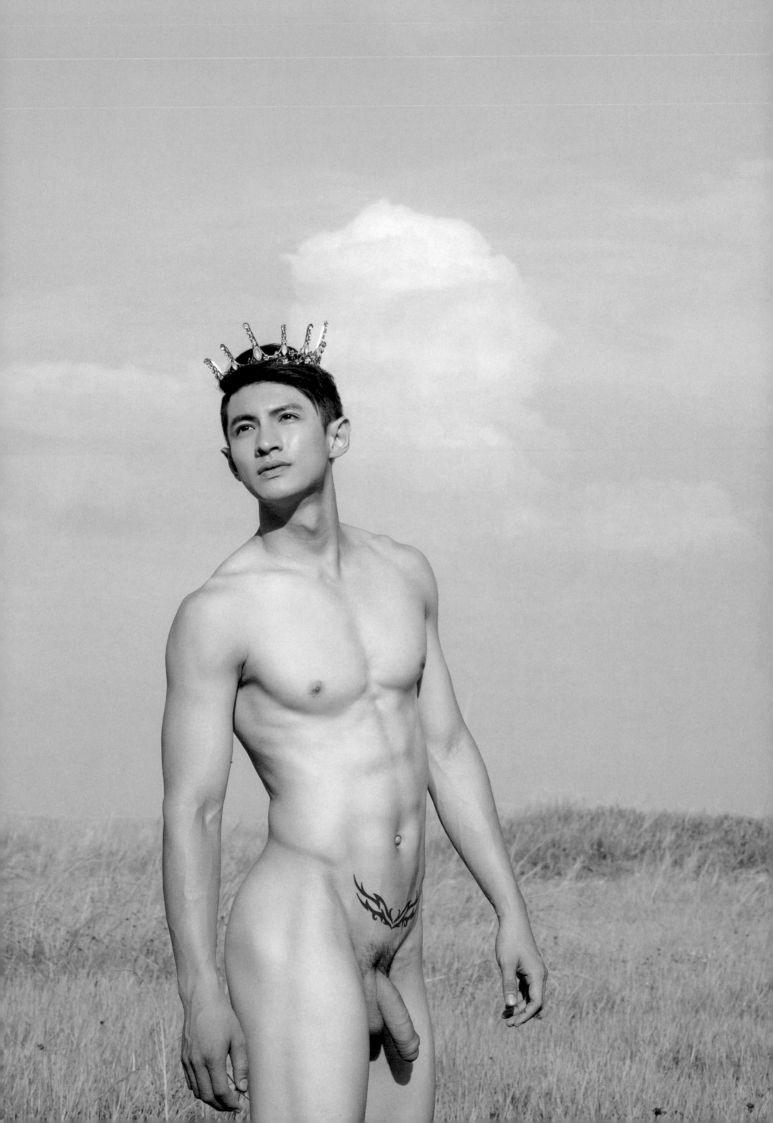

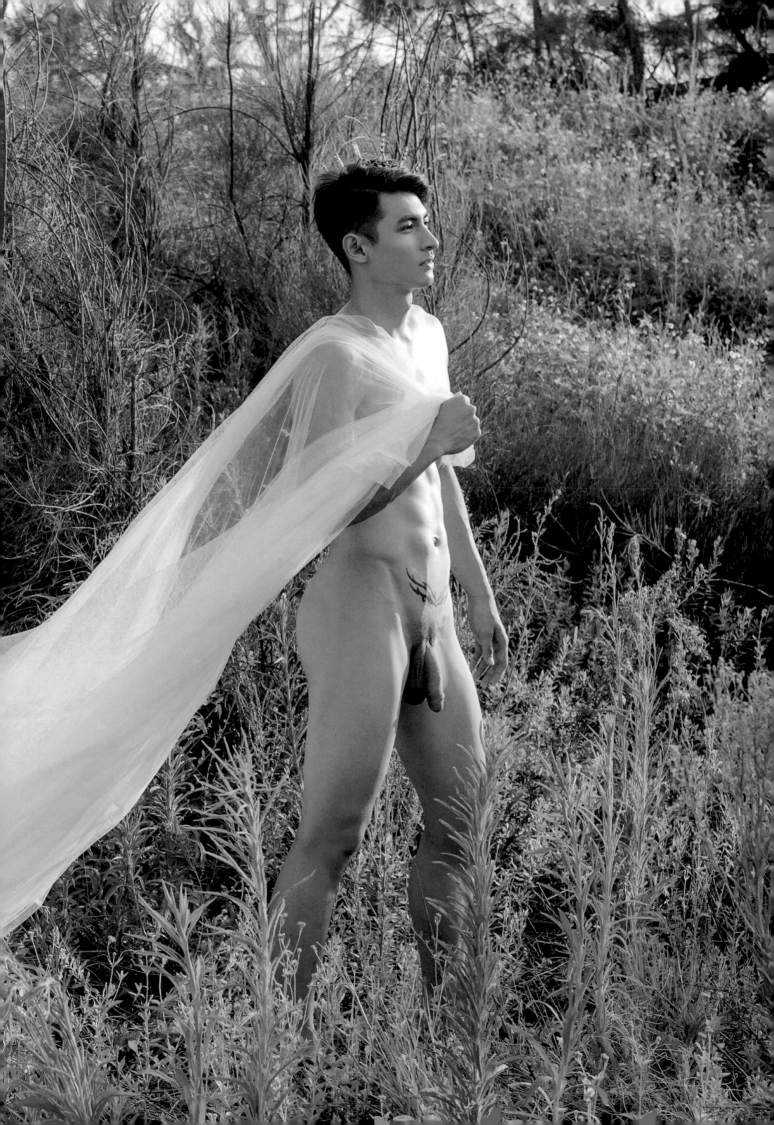

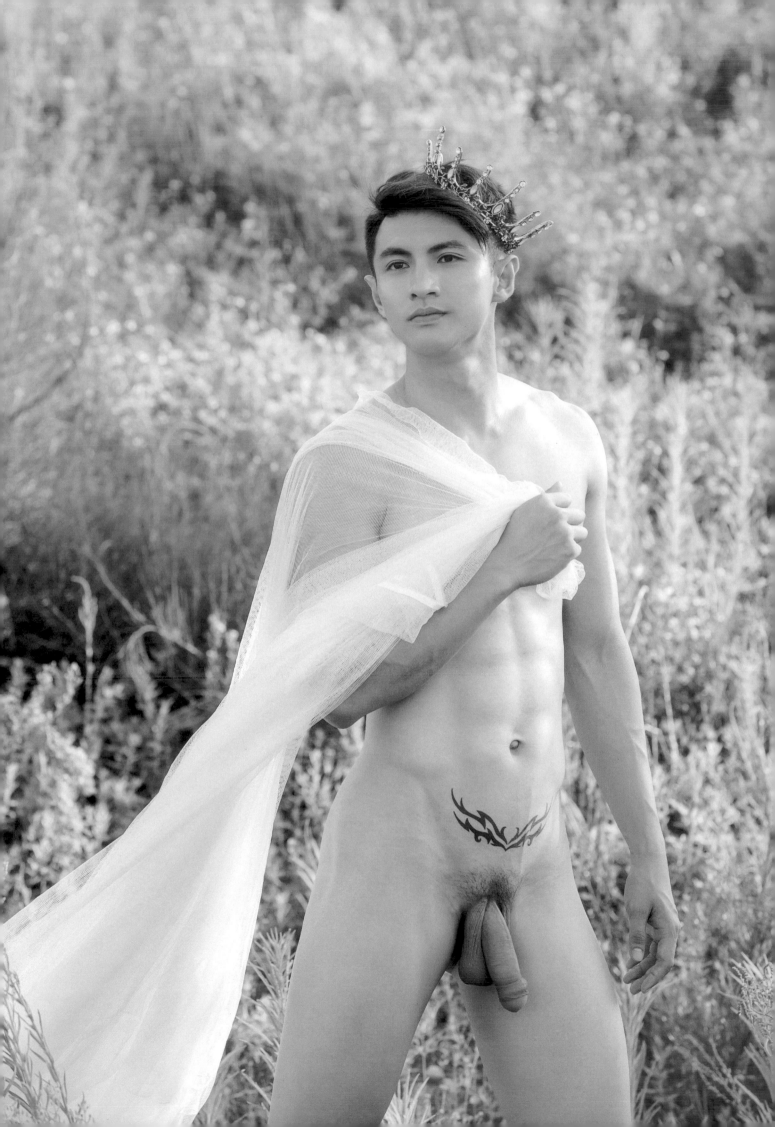

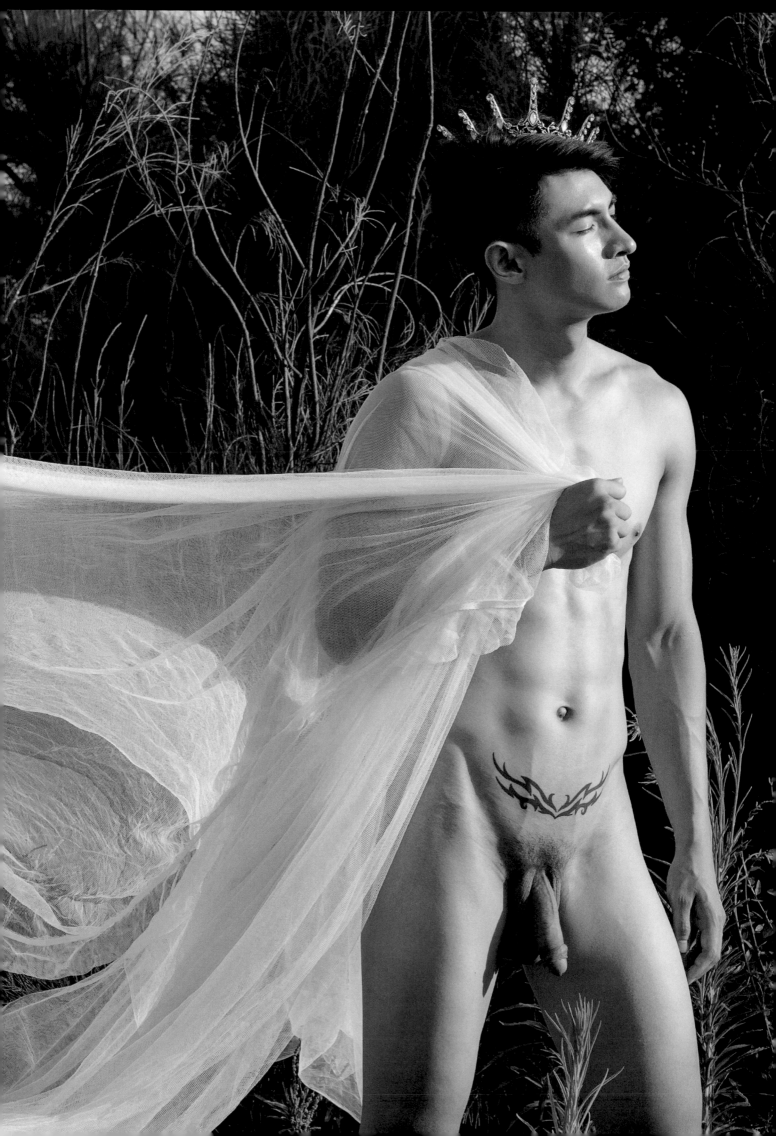

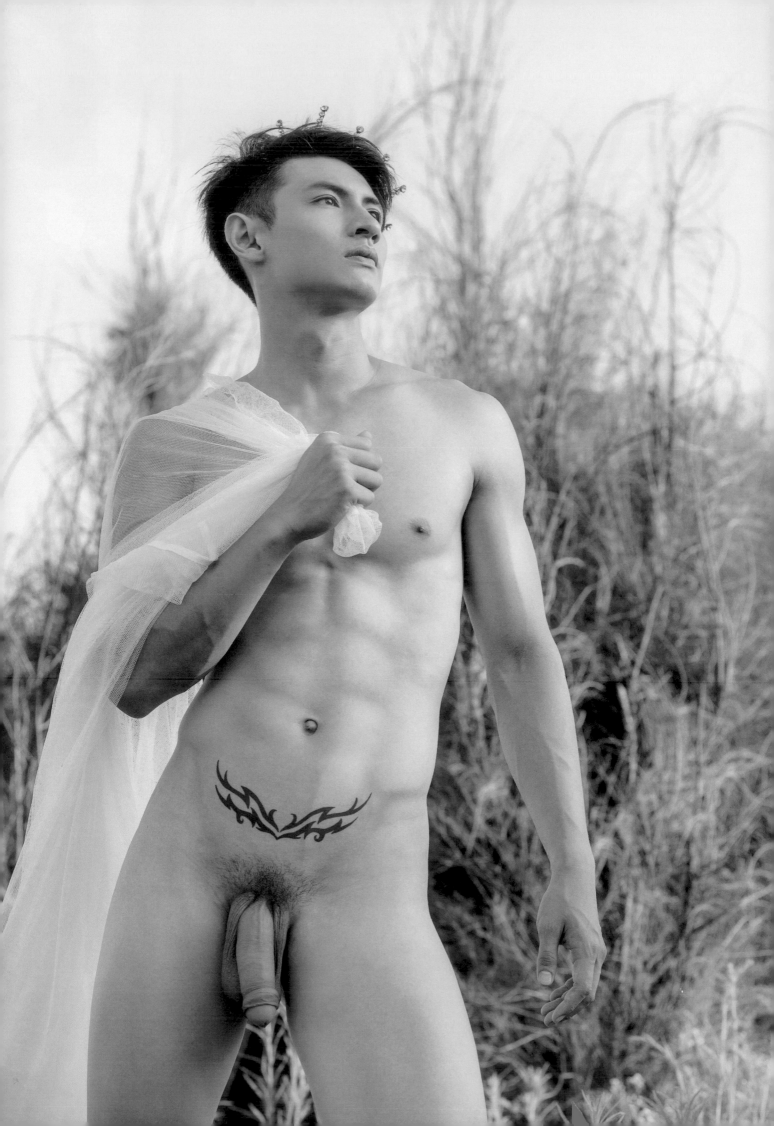

BLUEMEN

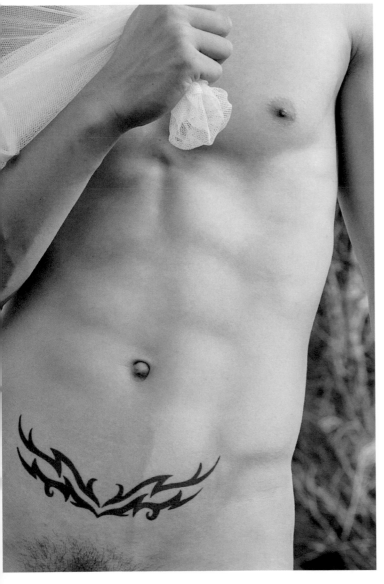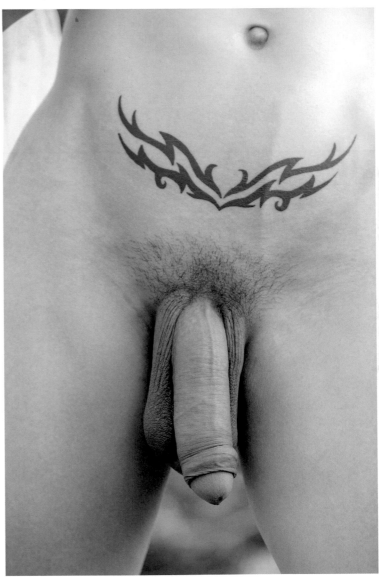

WANT

GIVE

YOU

MORE

BLUMEN

NO.14

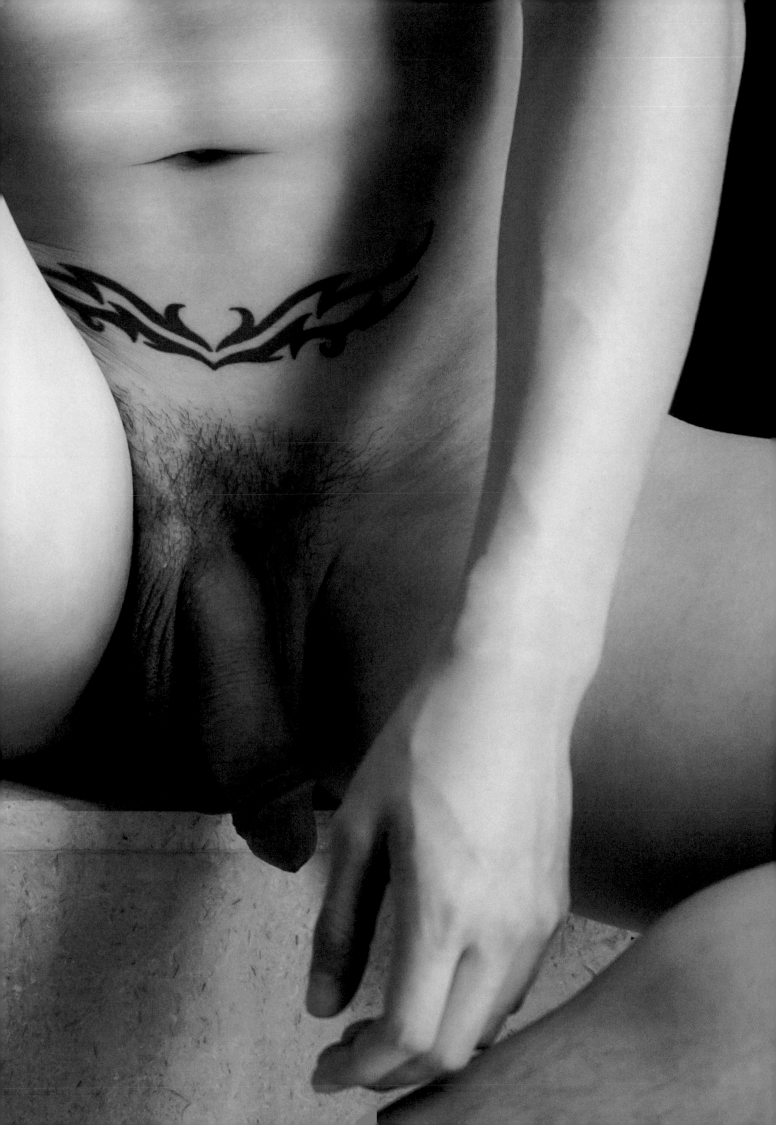

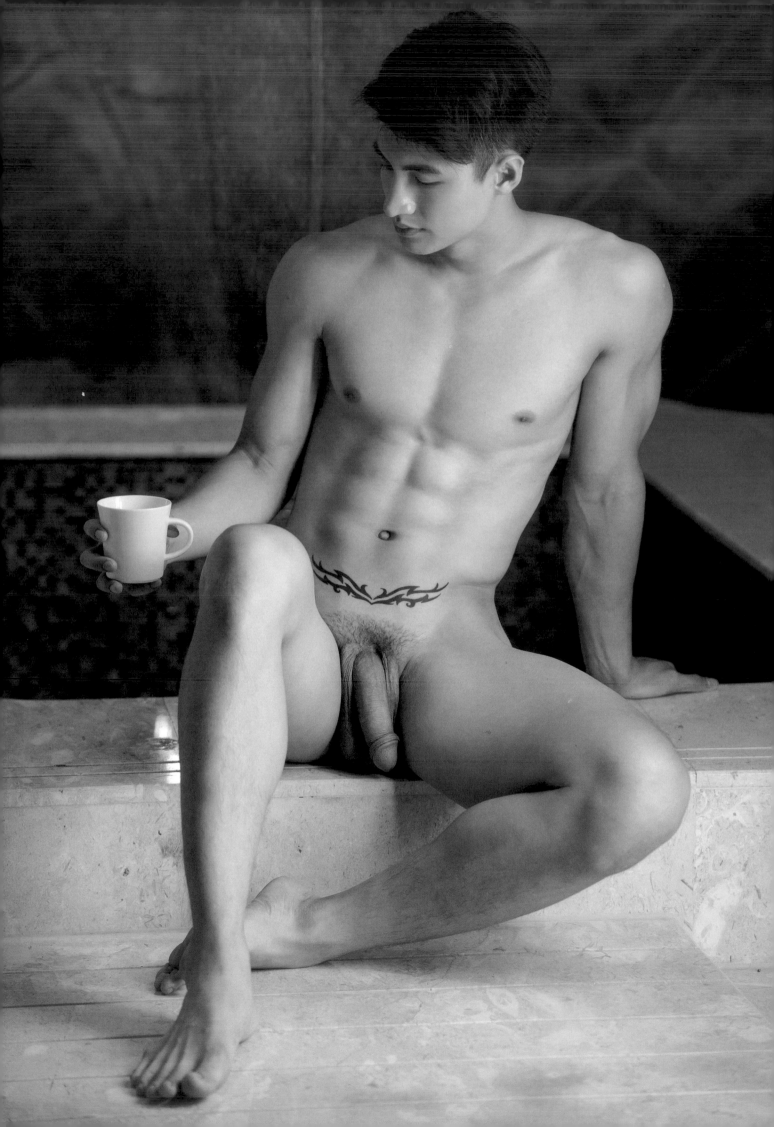

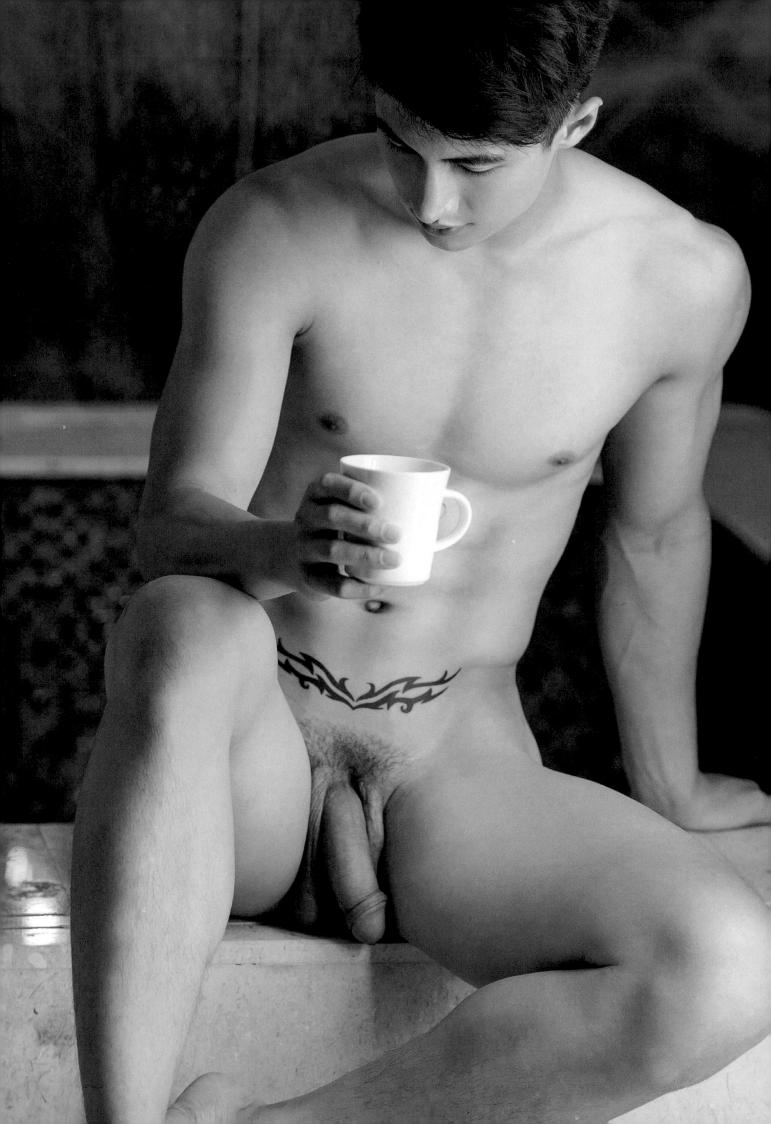

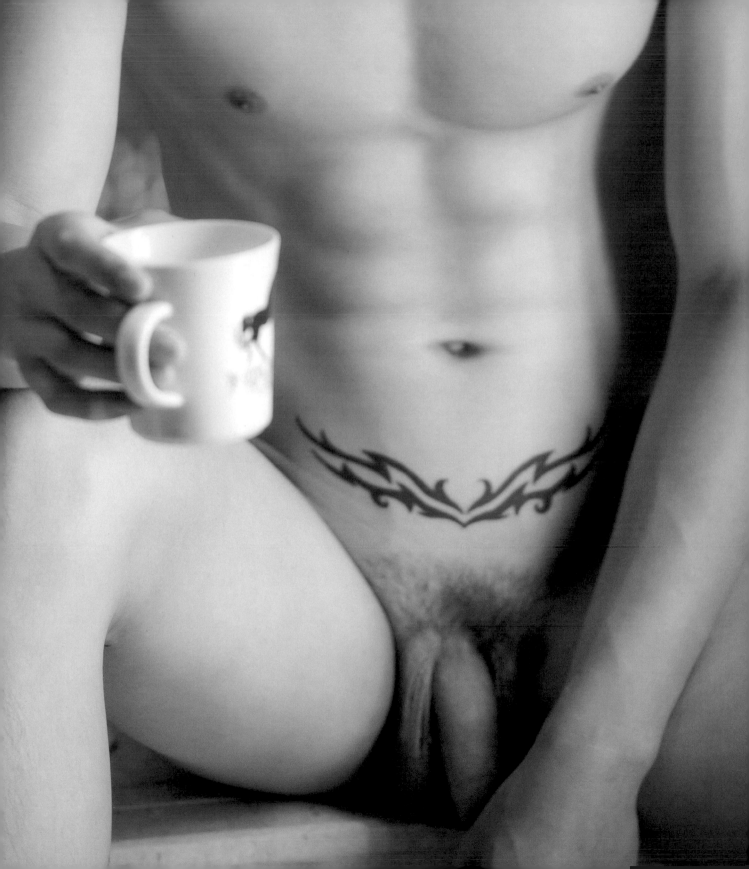

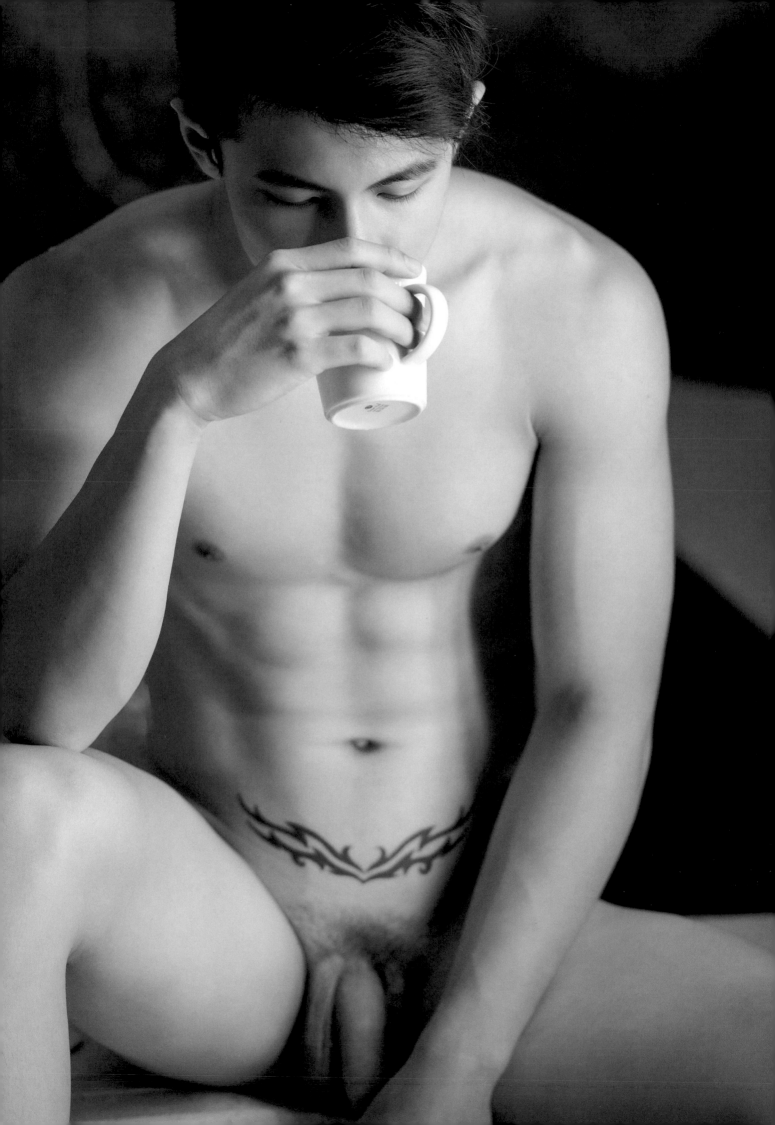

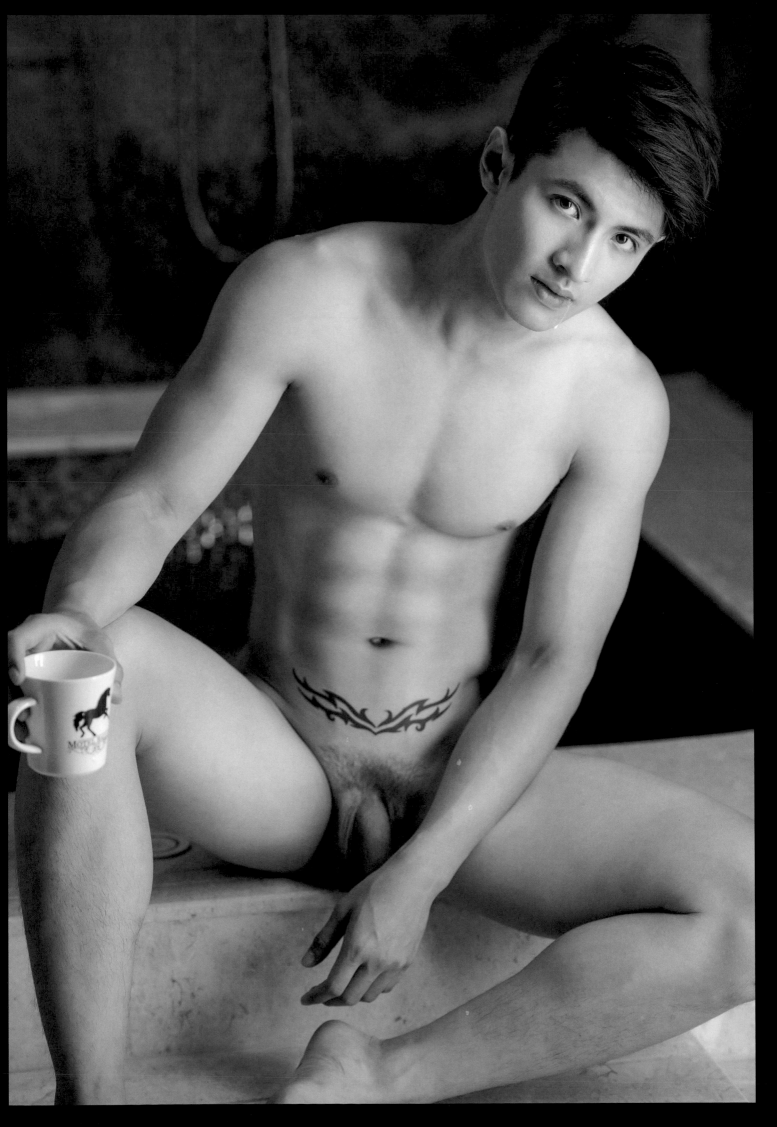

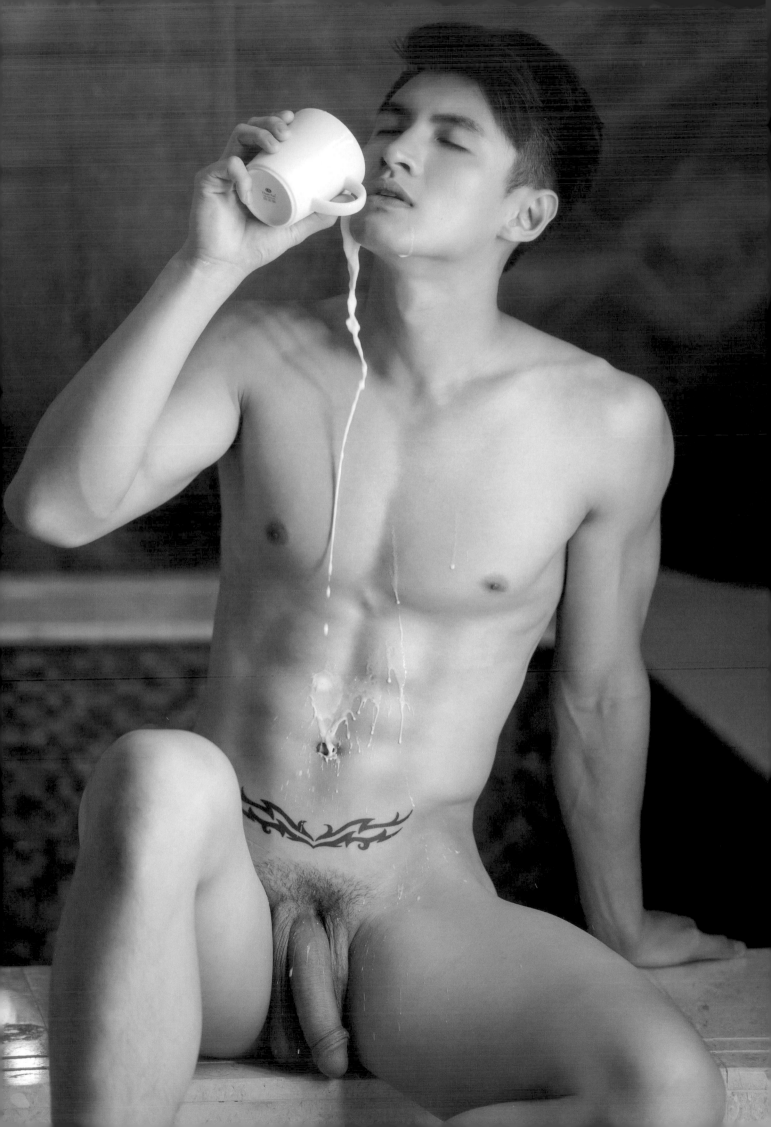

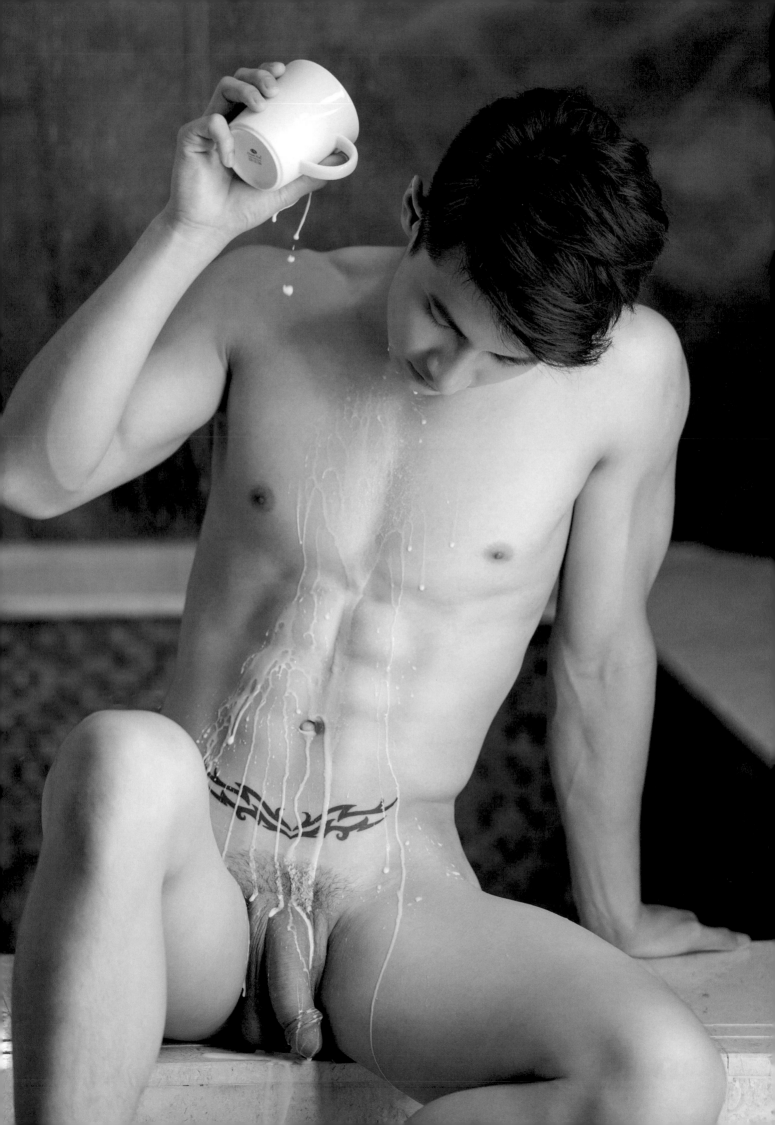

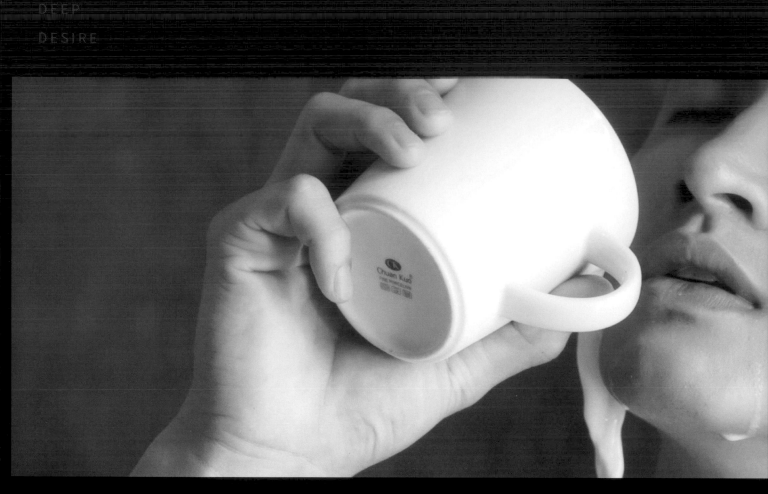

GET CLOSE TO ME

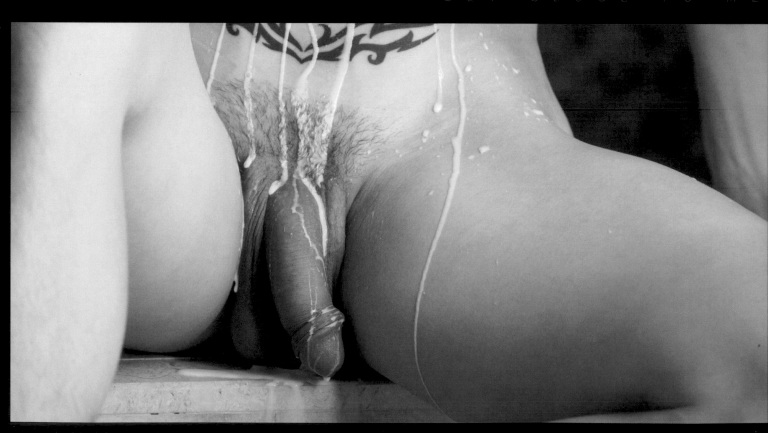

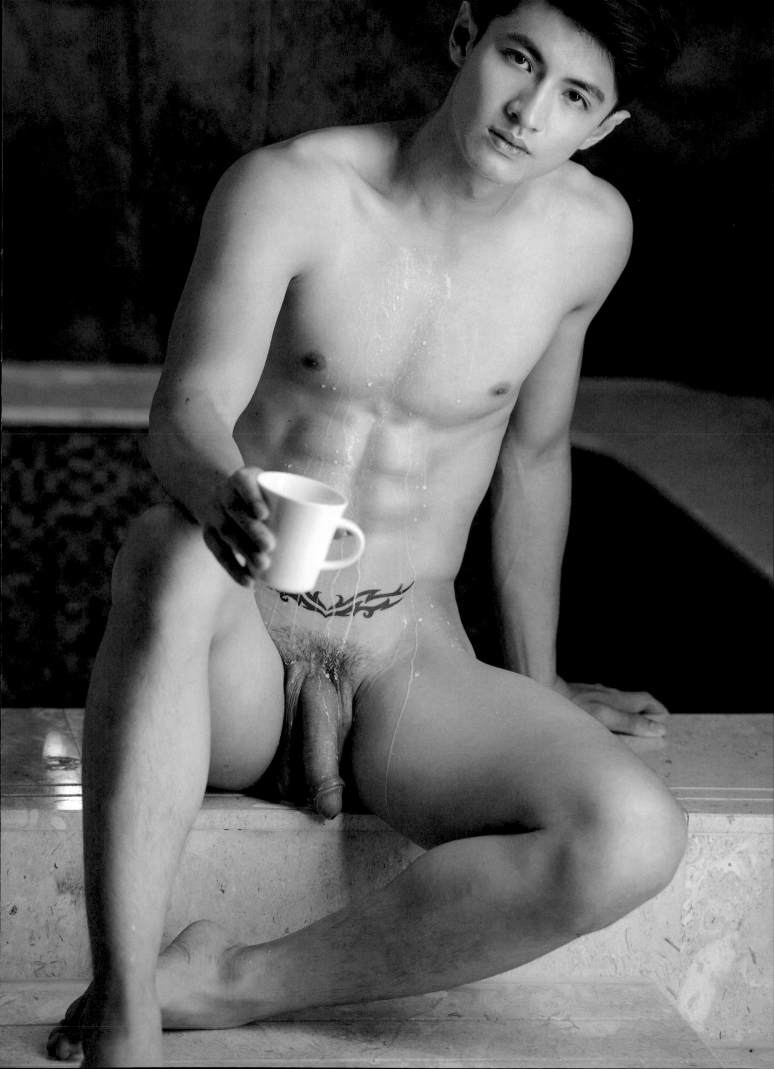

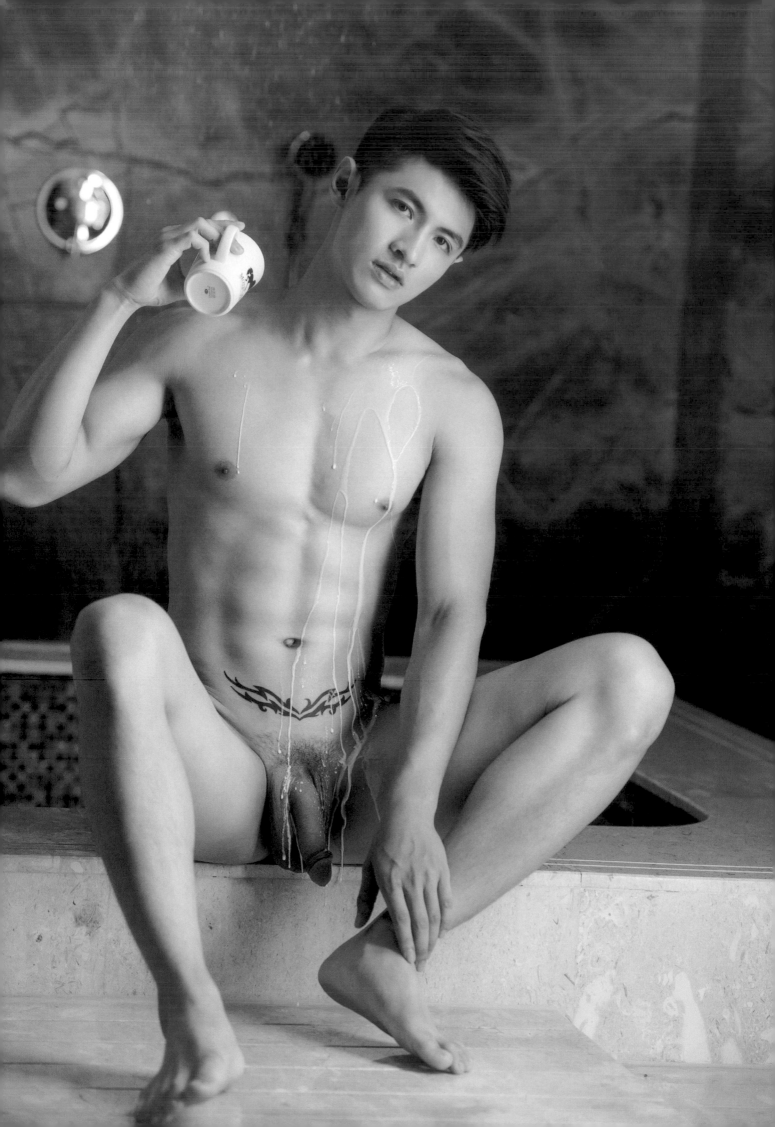

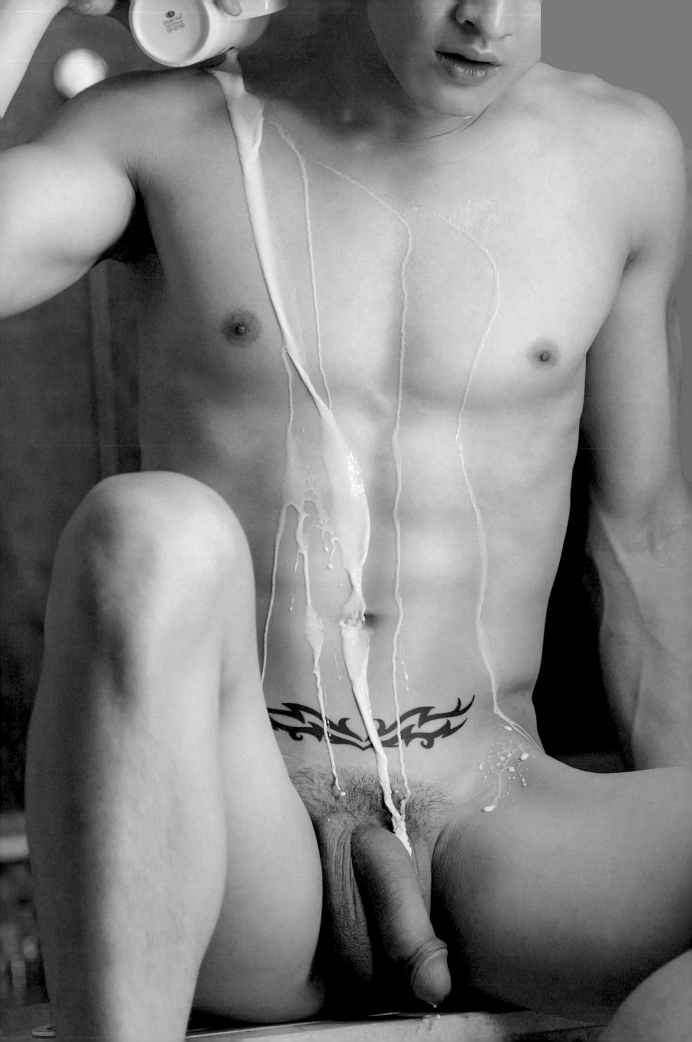

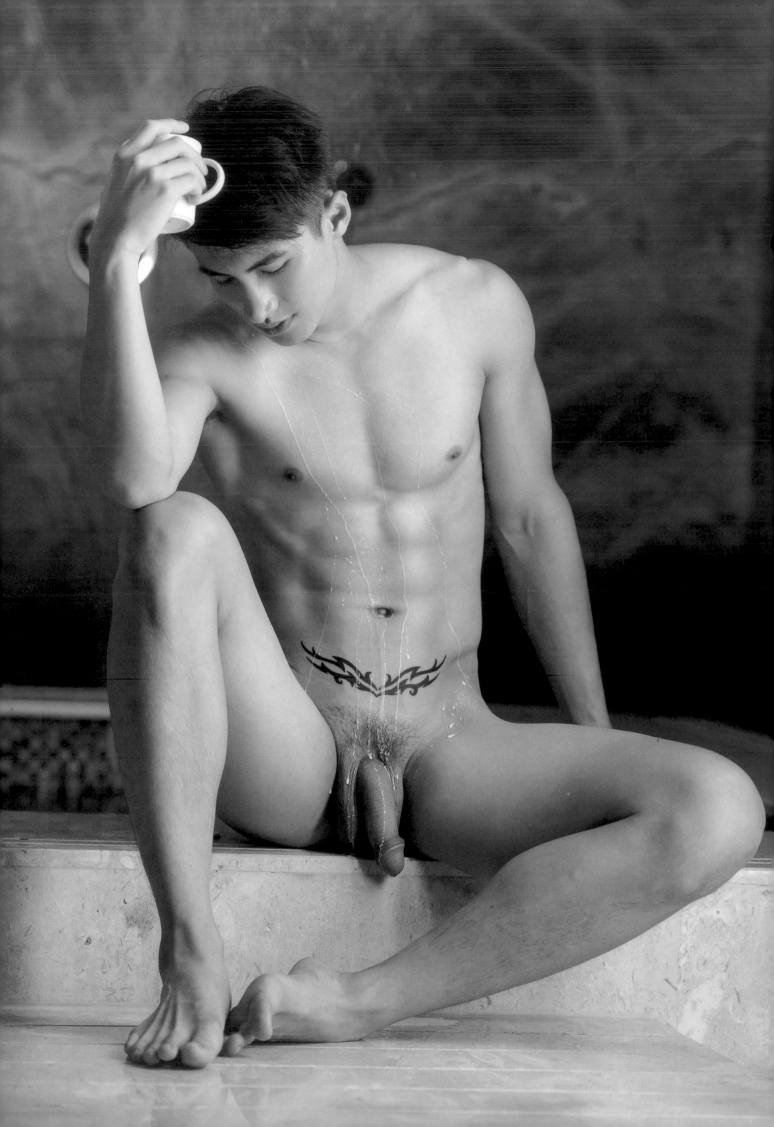

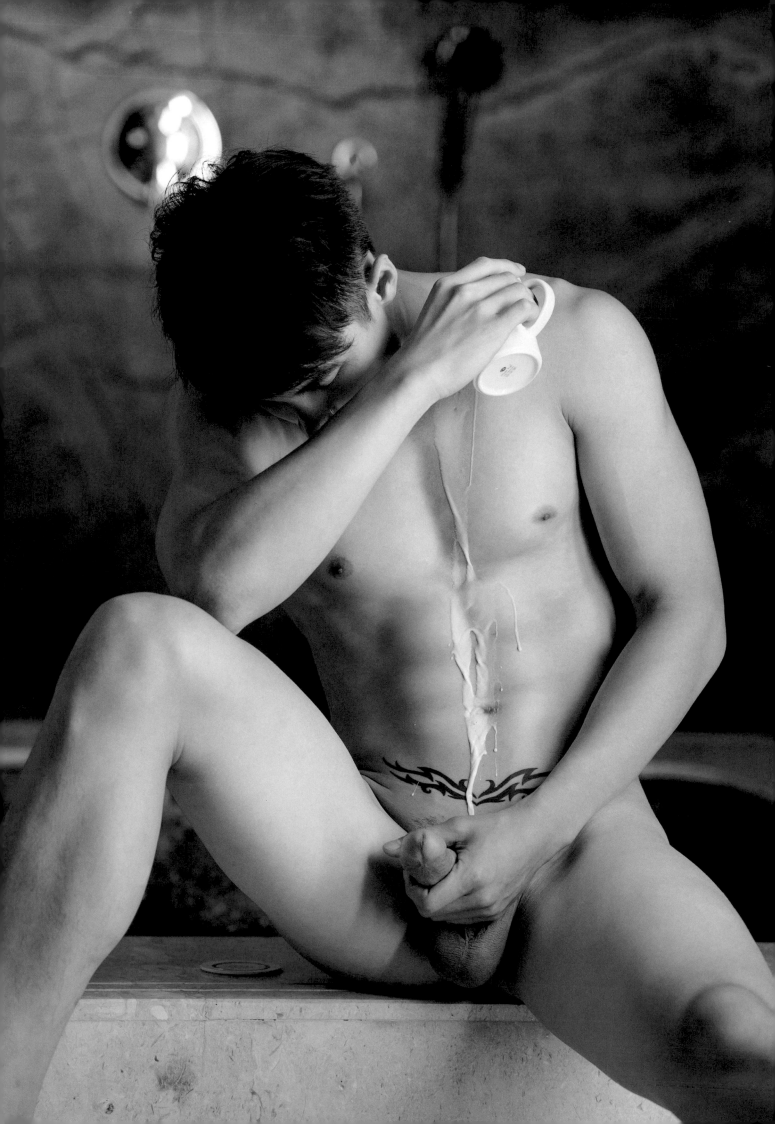

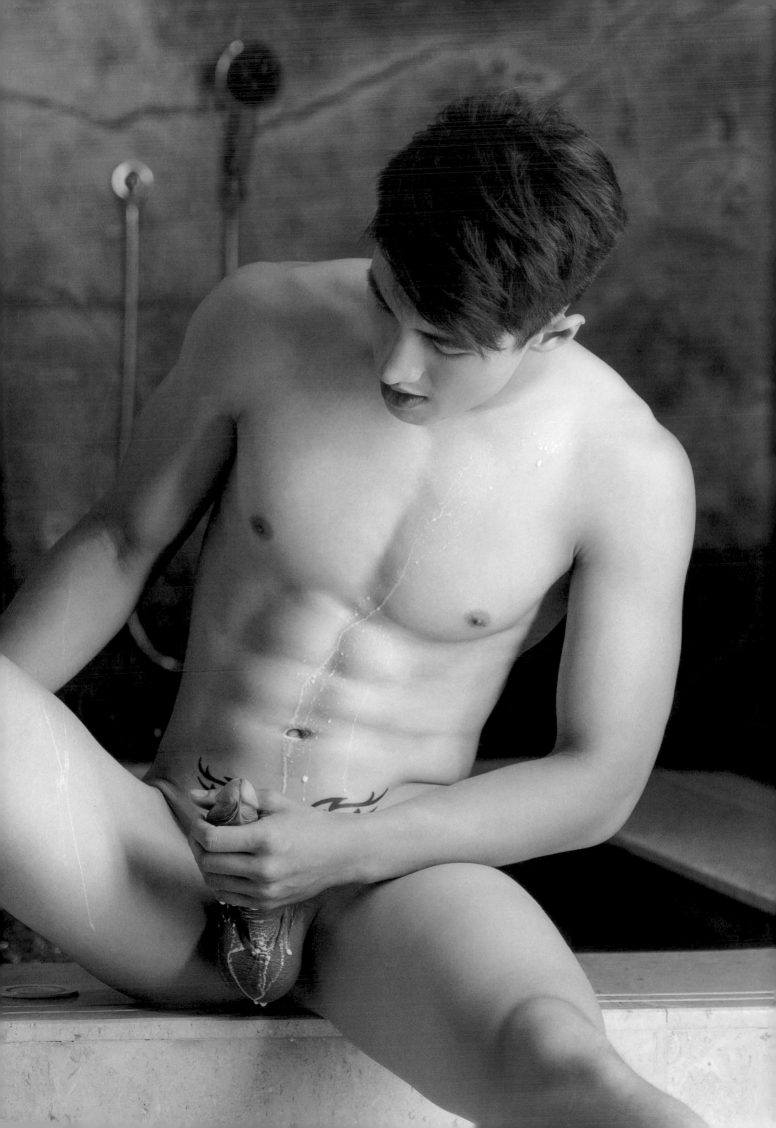

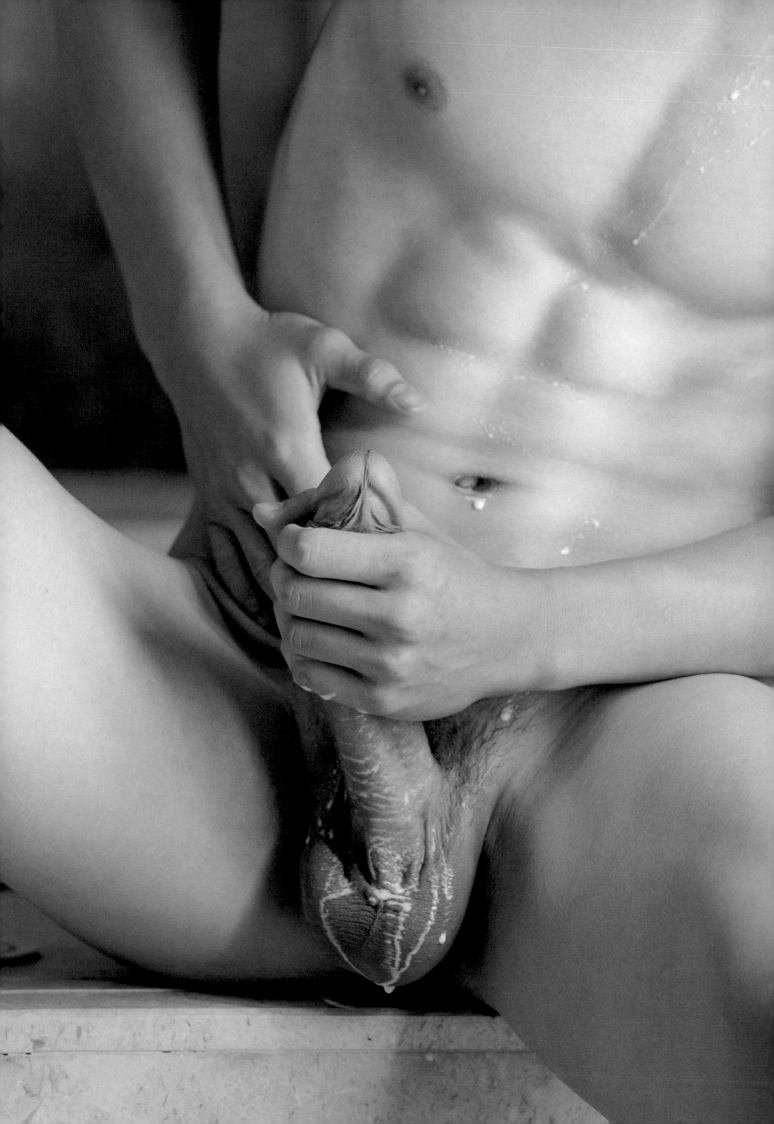

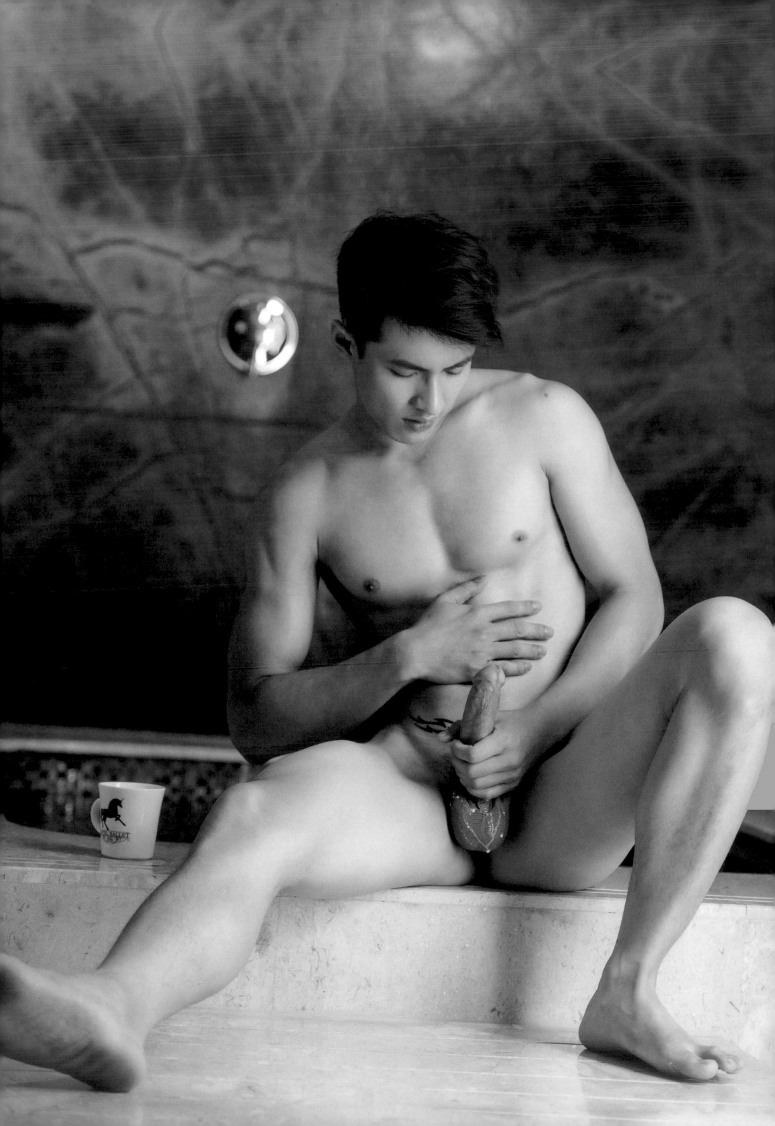

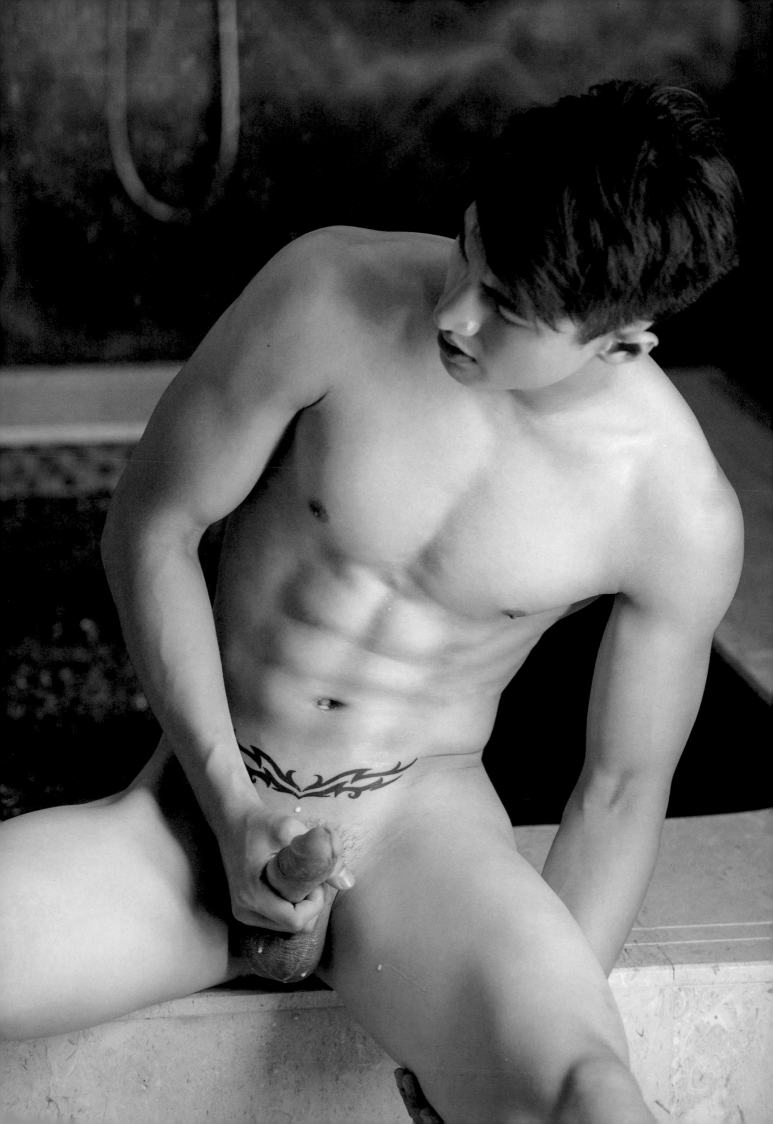

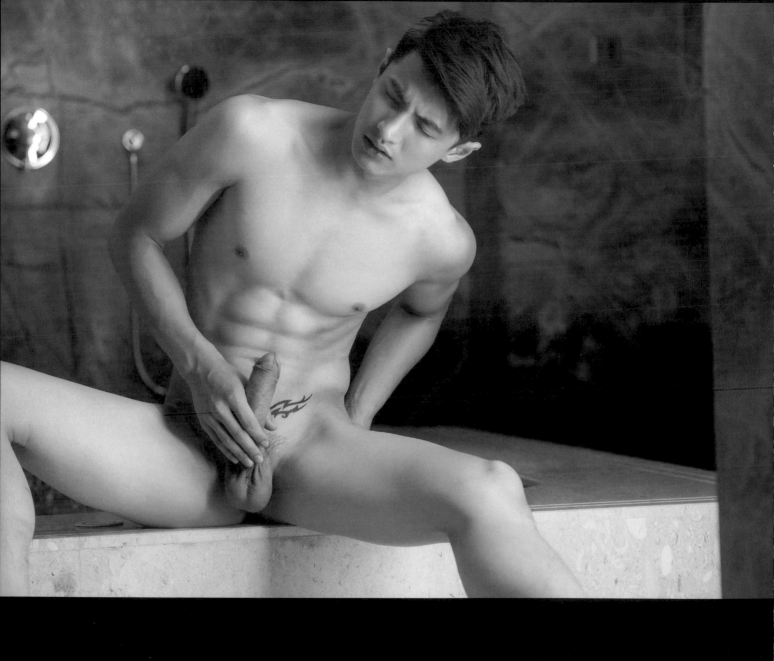

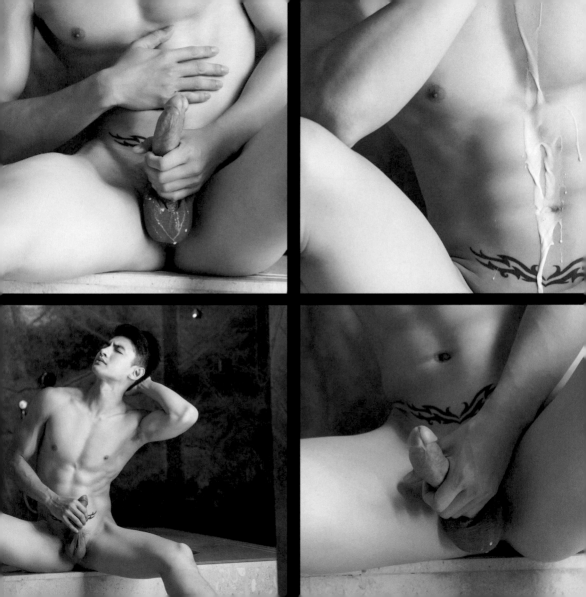

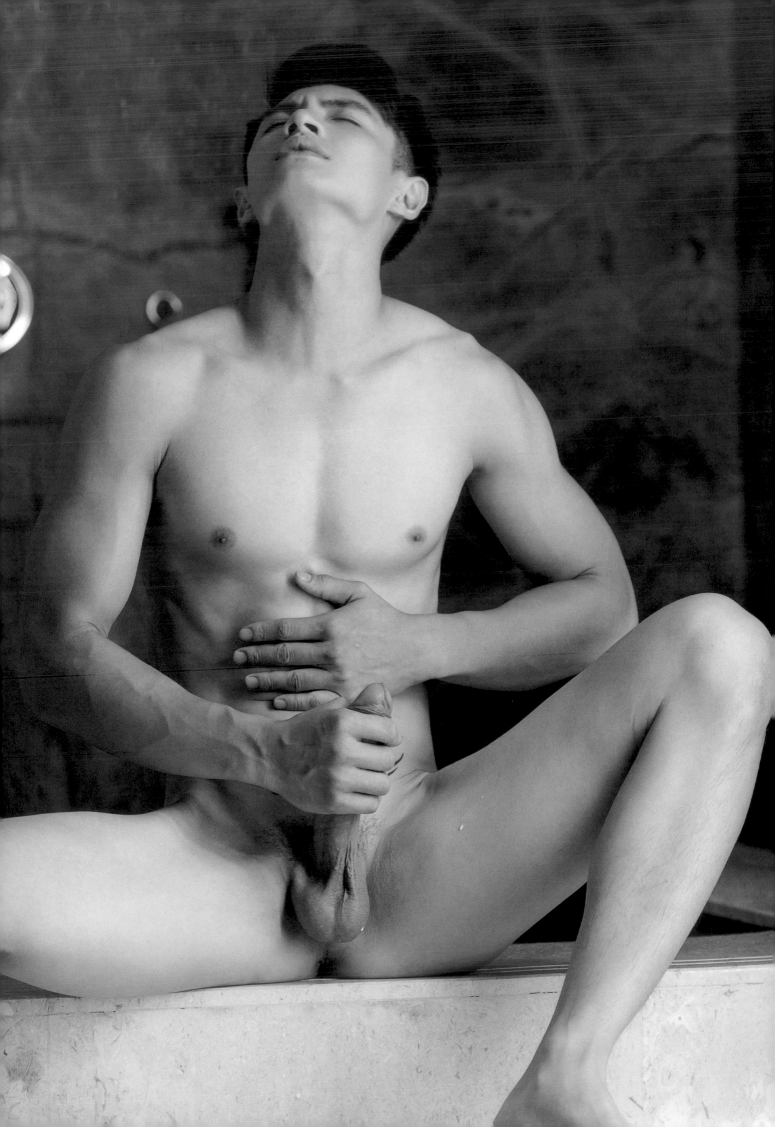

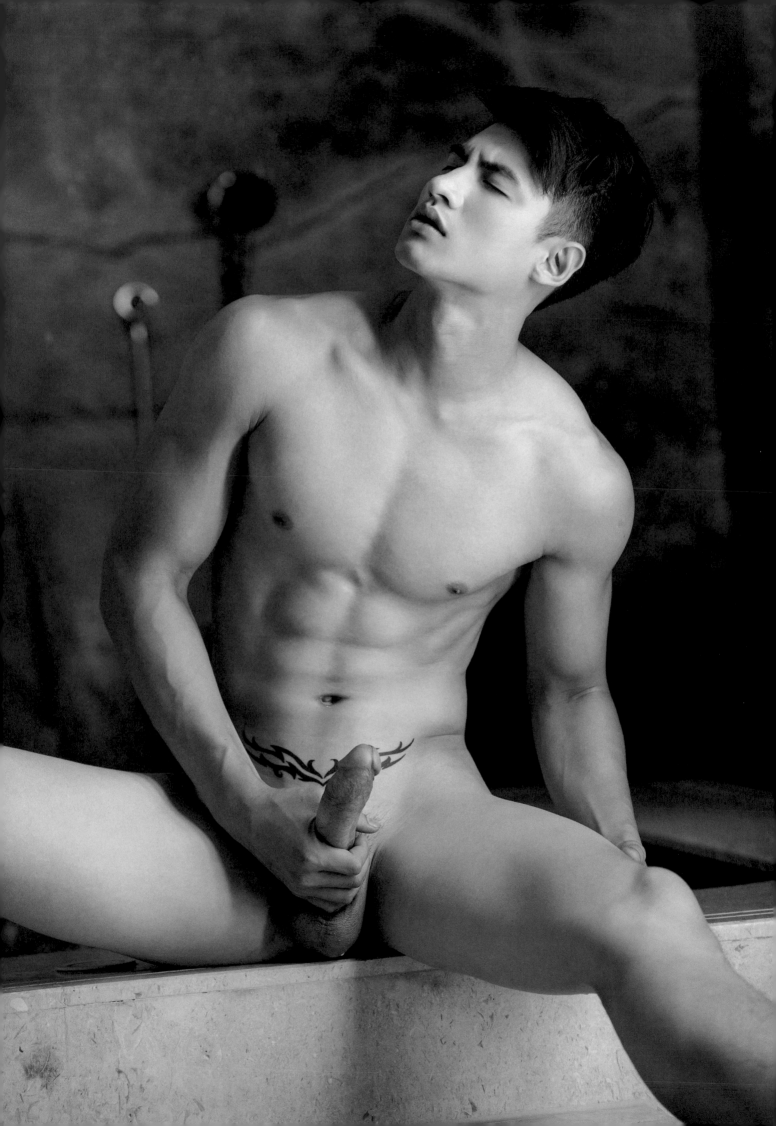

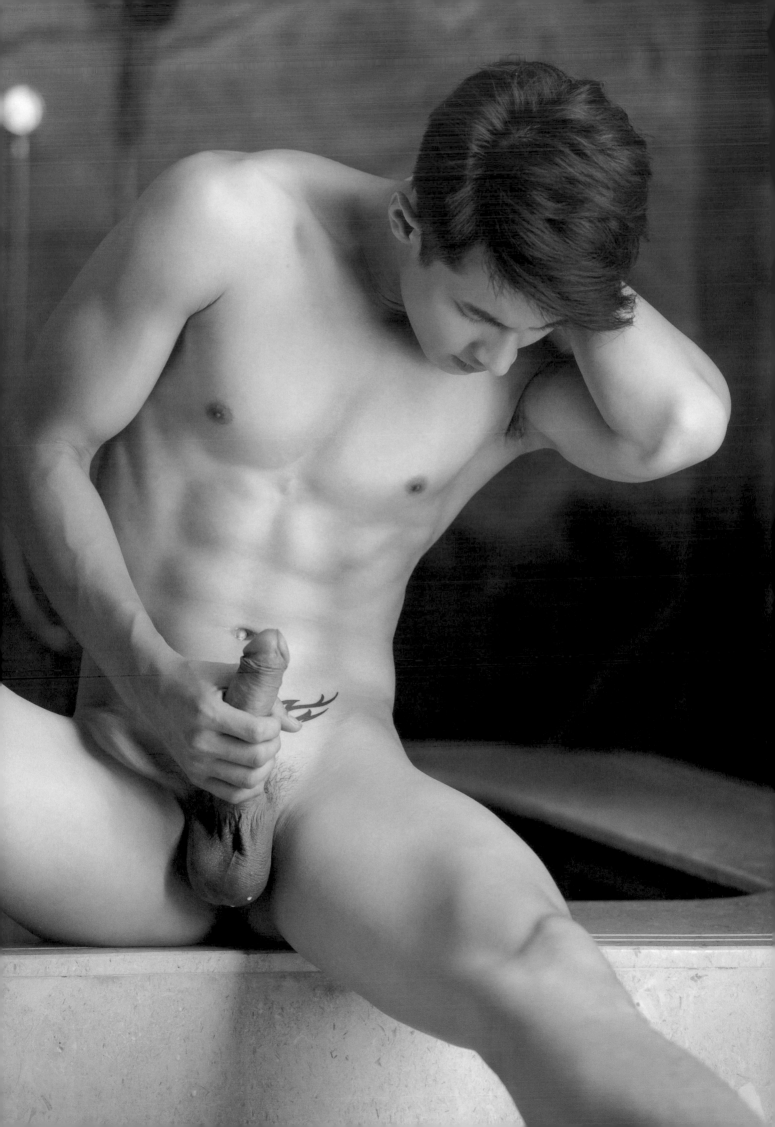

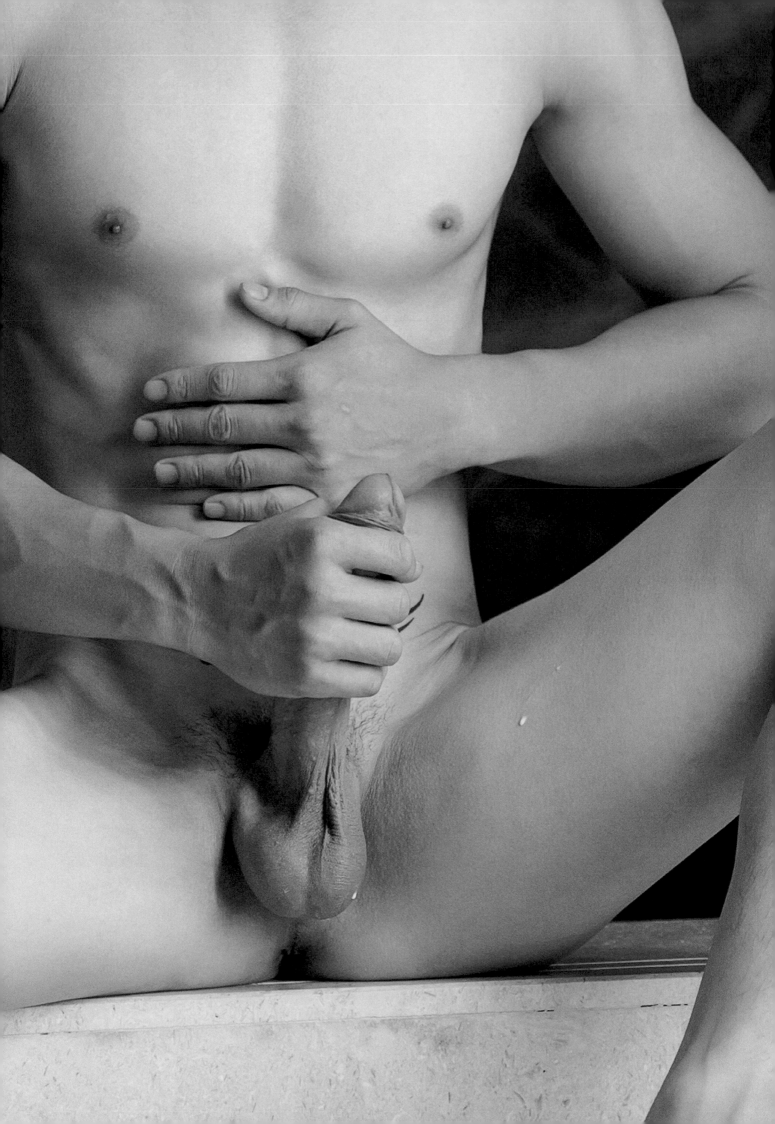

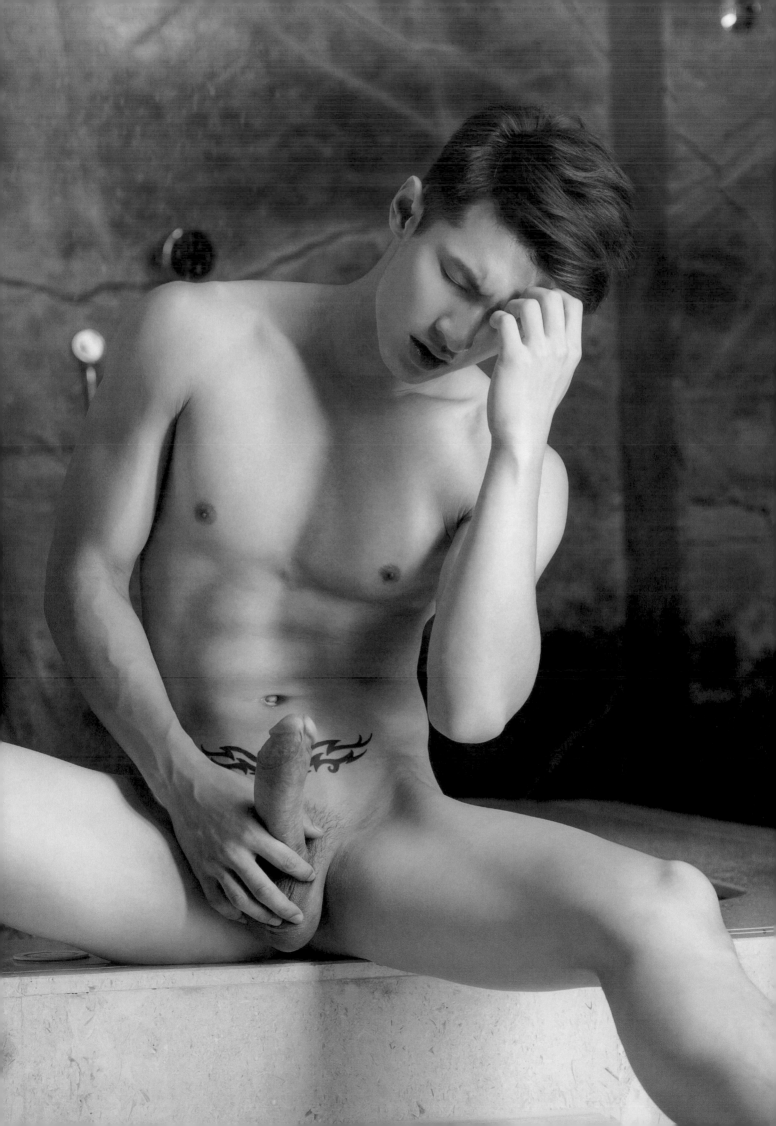

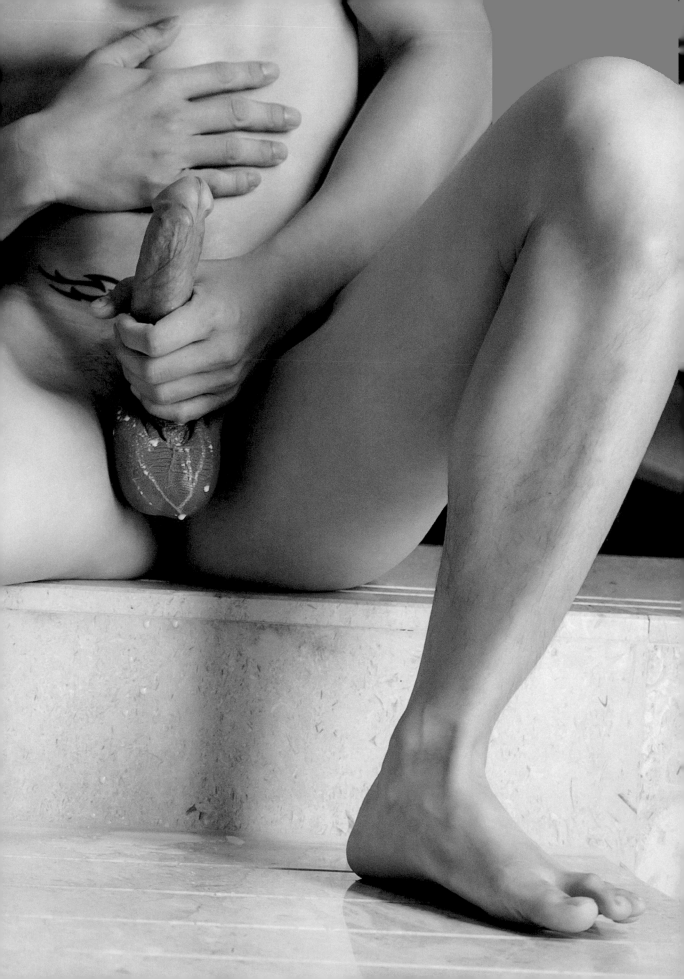

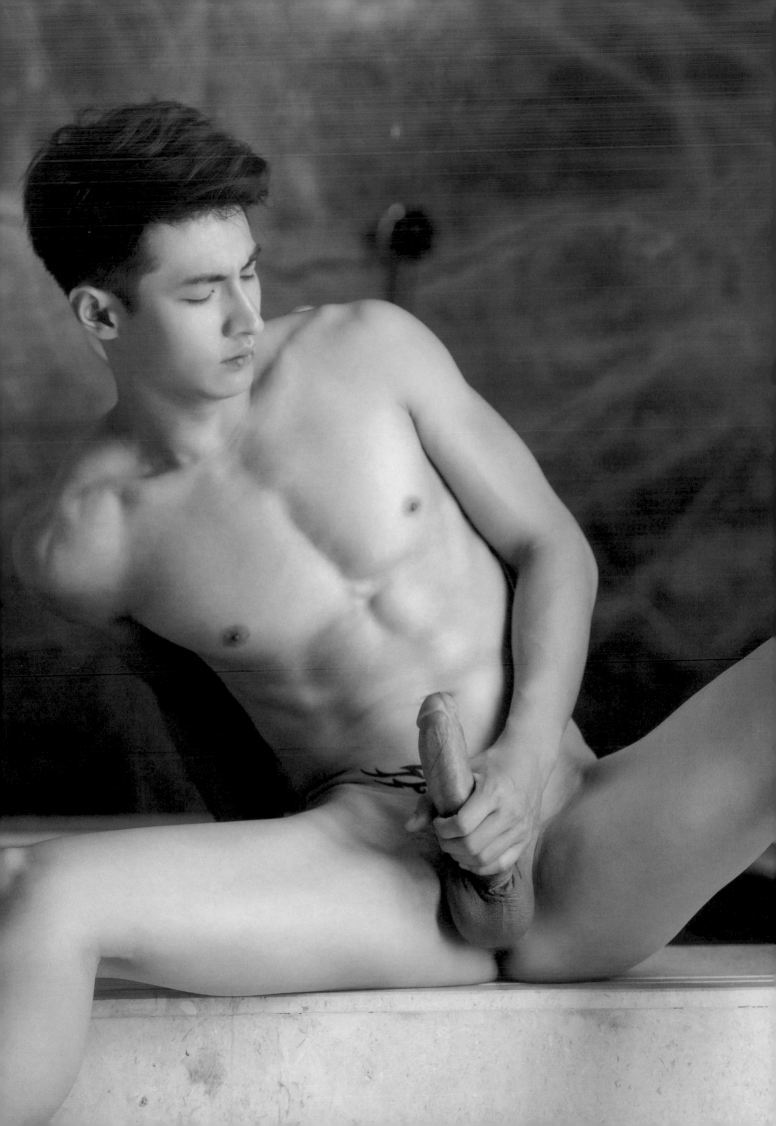

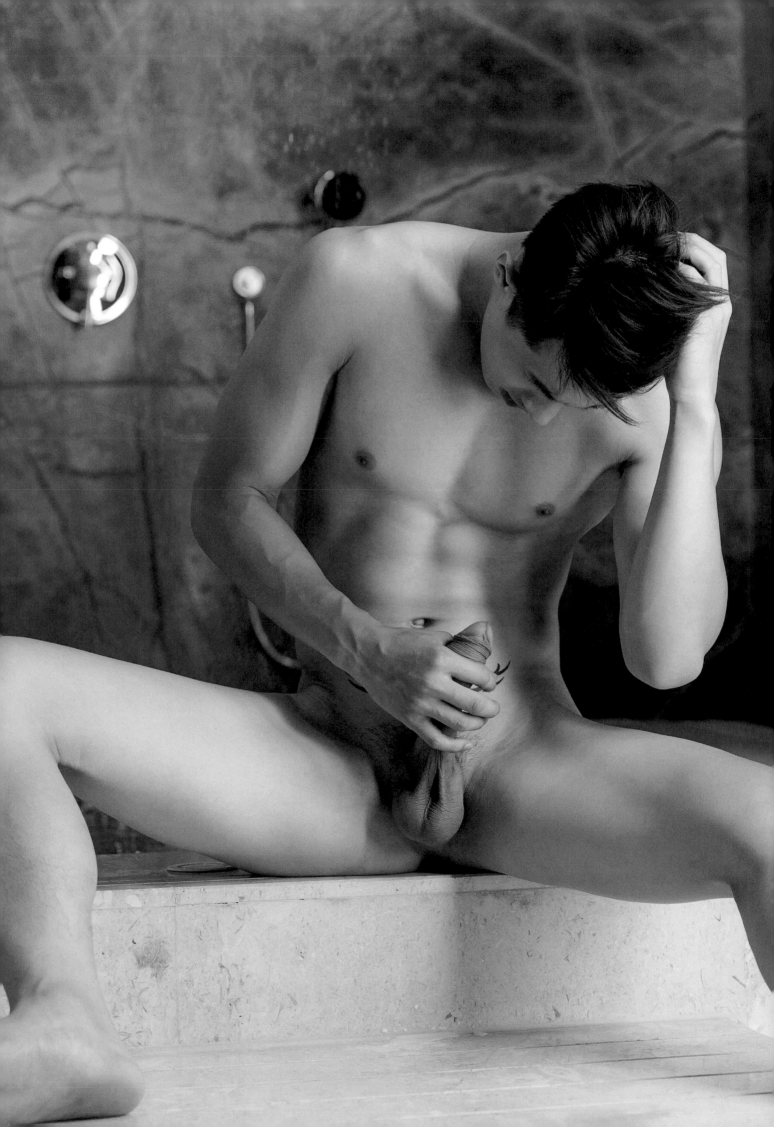

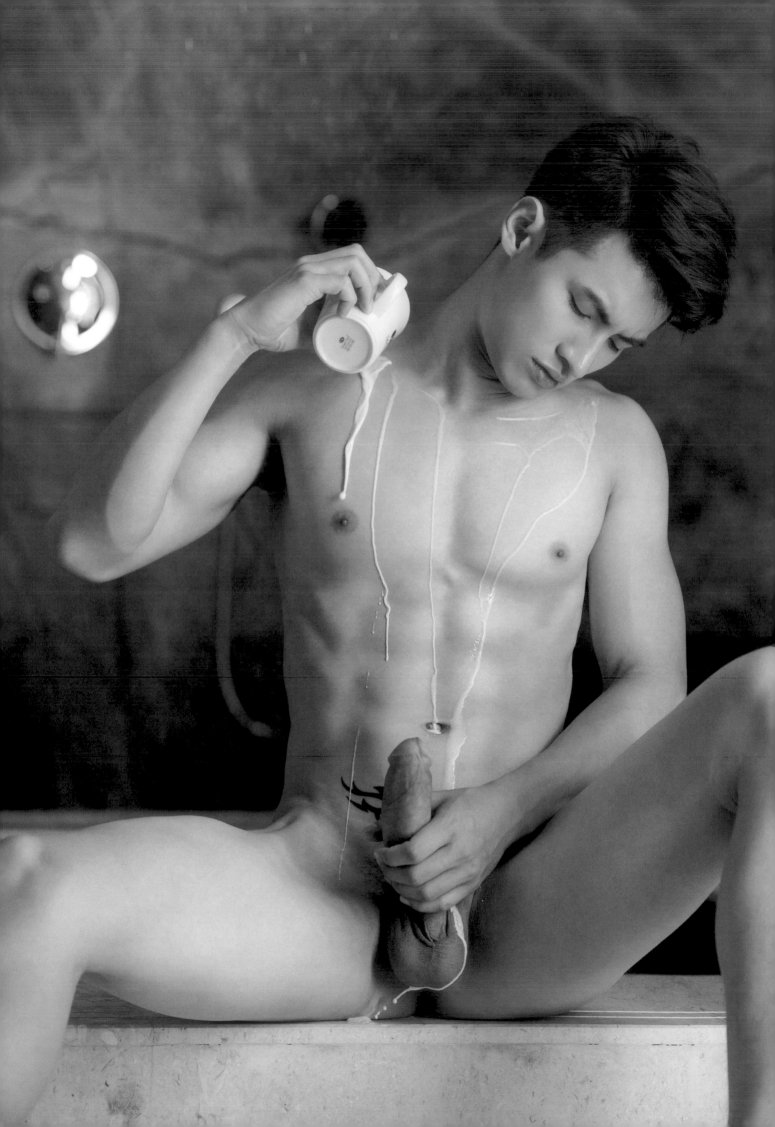

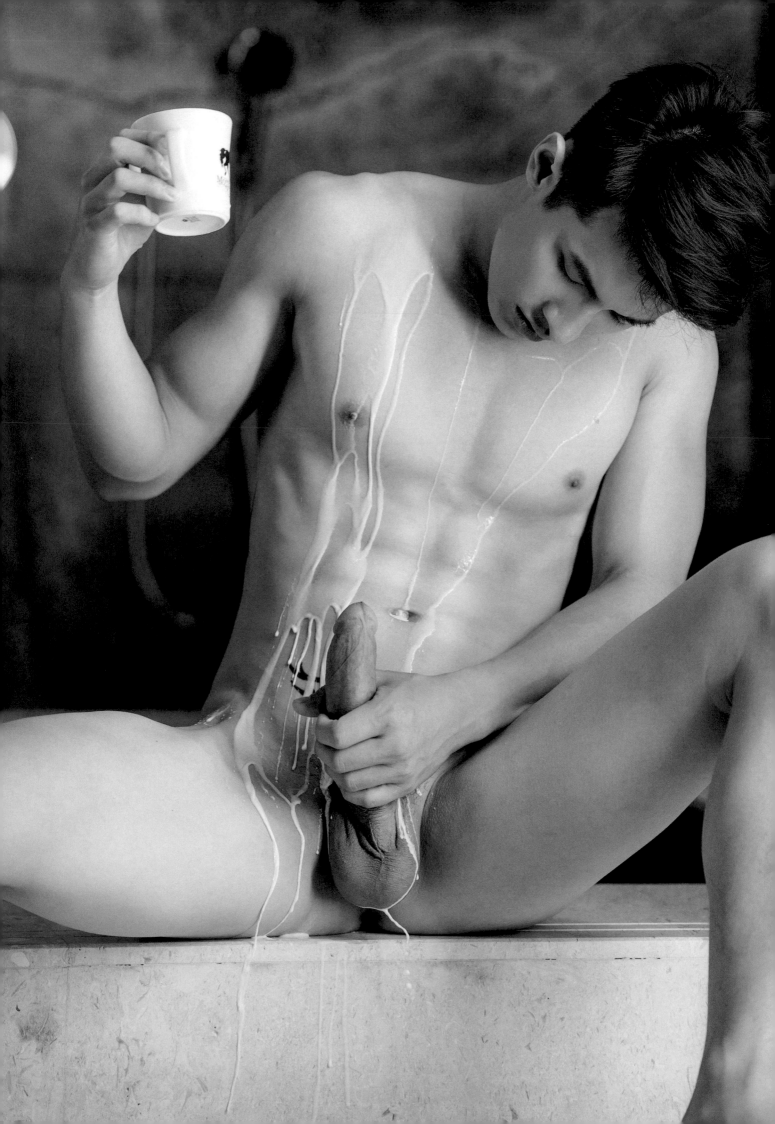

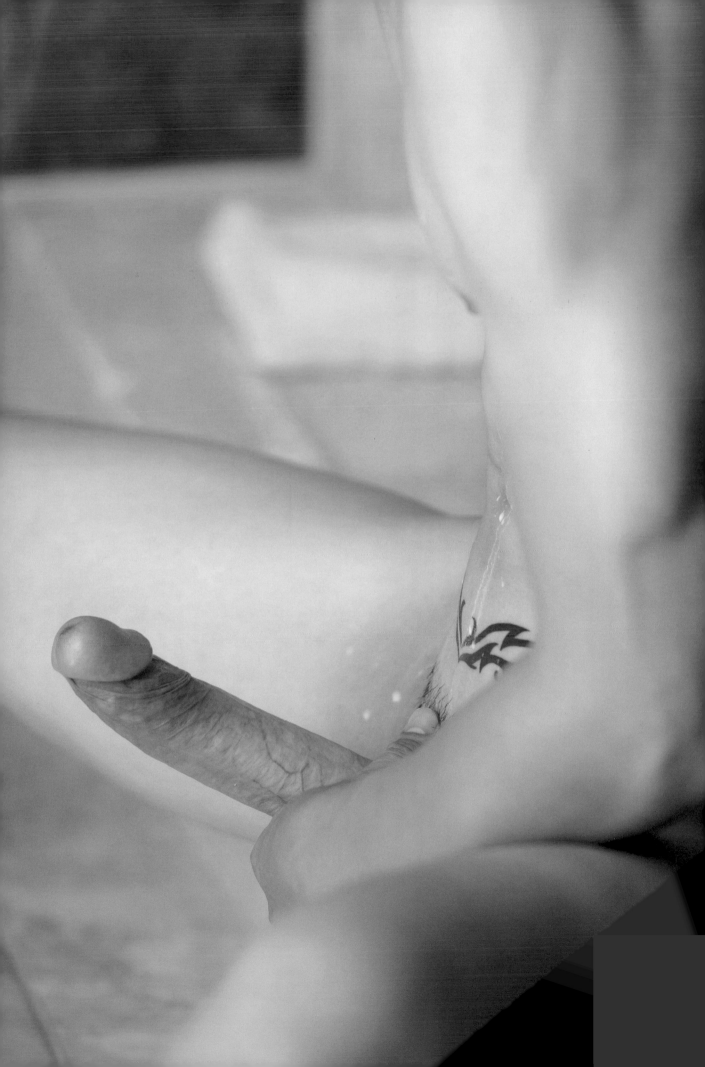

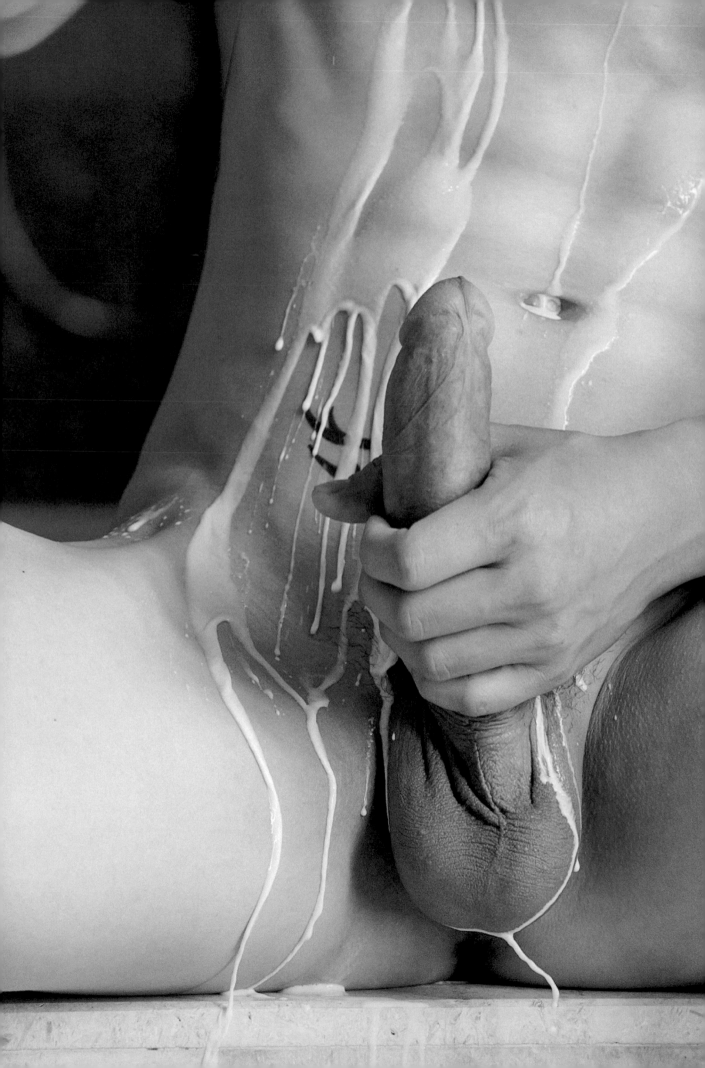

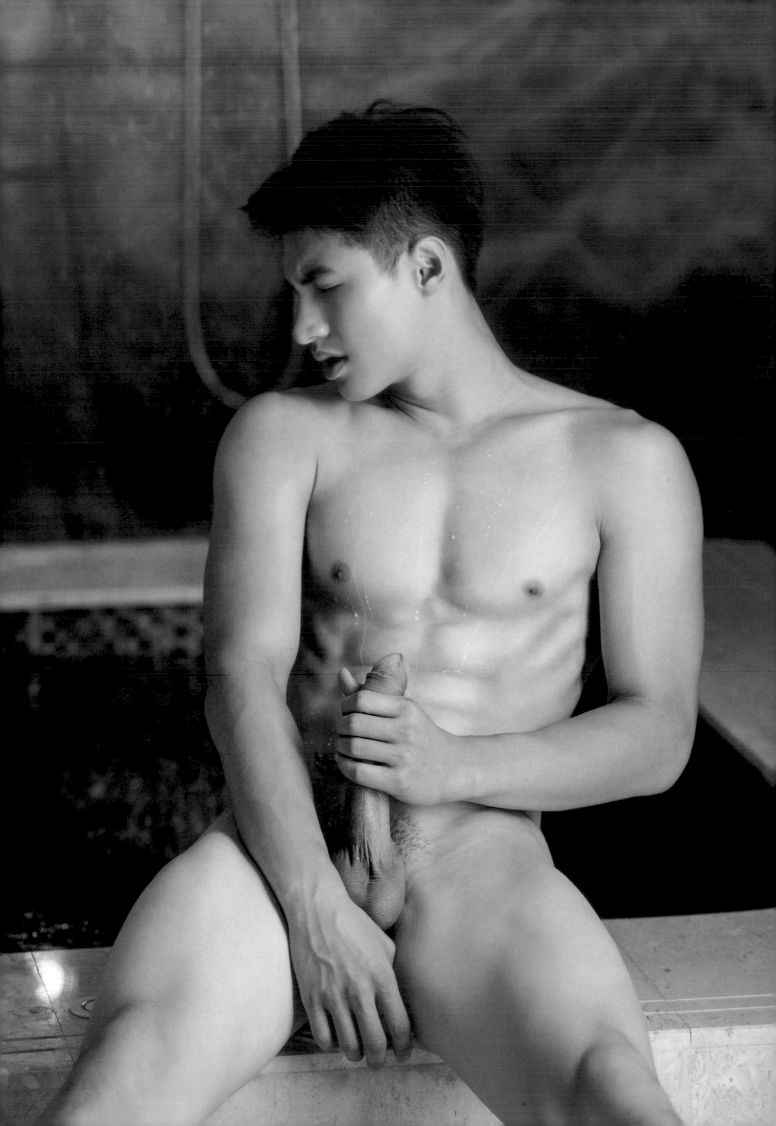

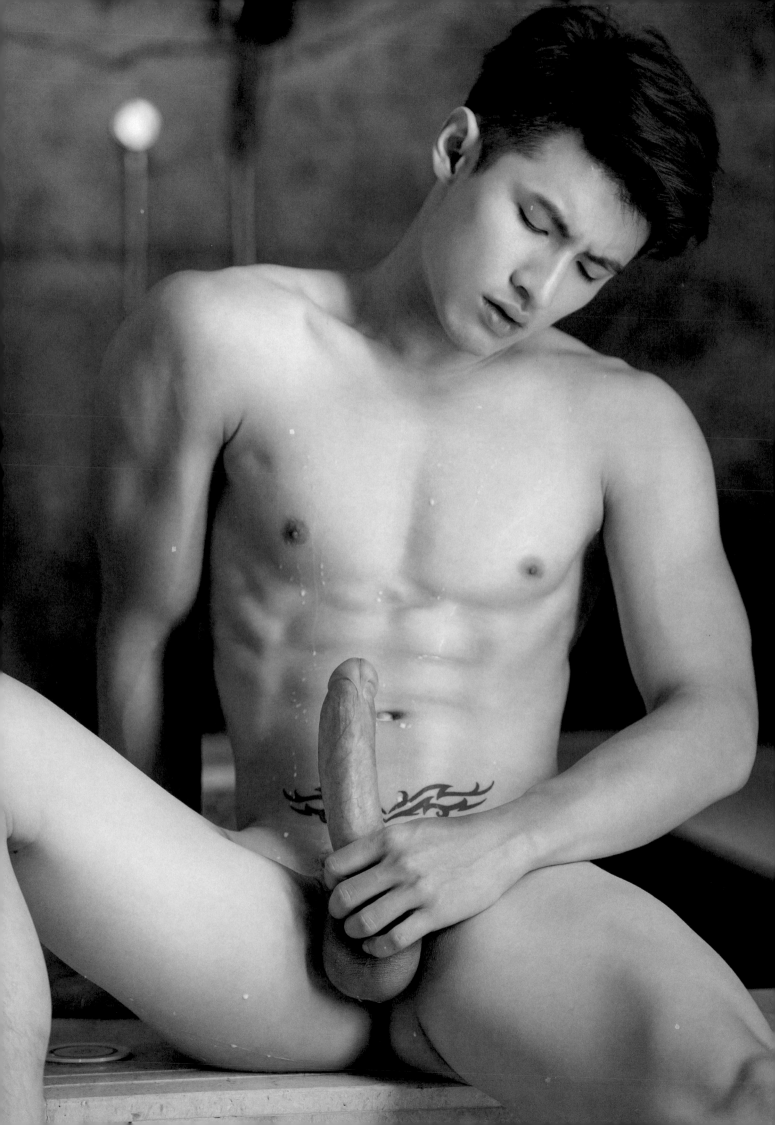

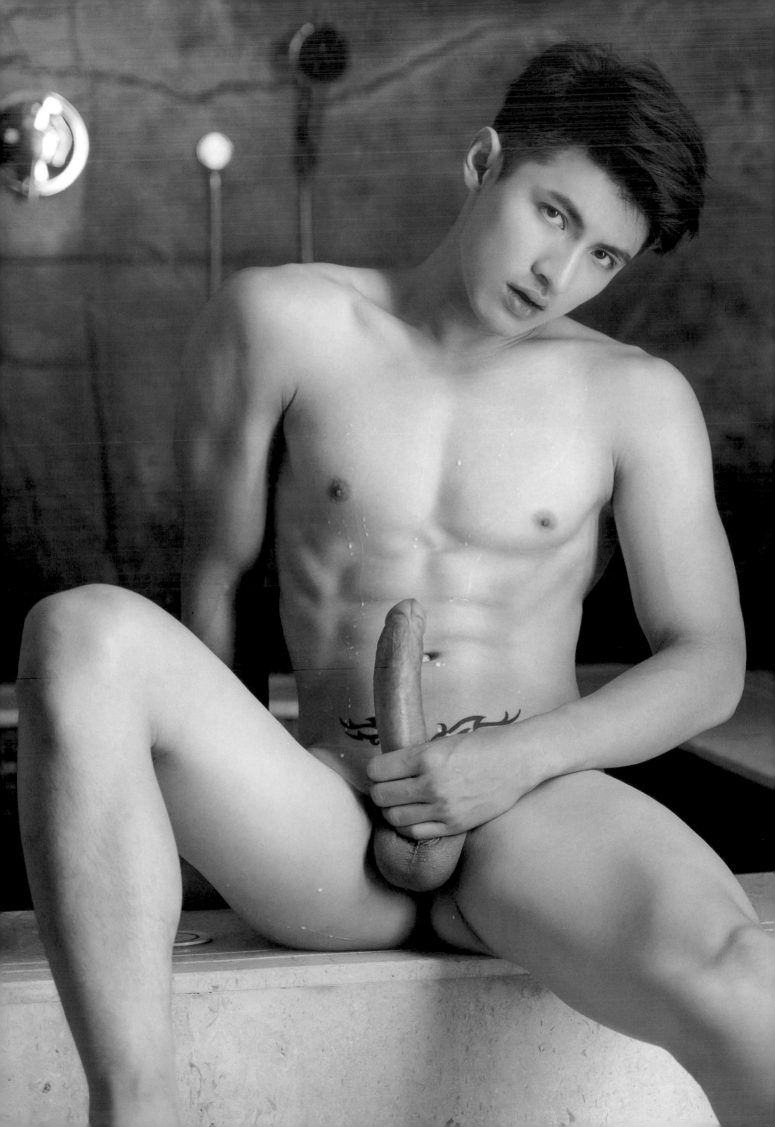

THE

BODY

IS

GETTING

HOTTER

I CAN'T

CONTROL

MYSELF

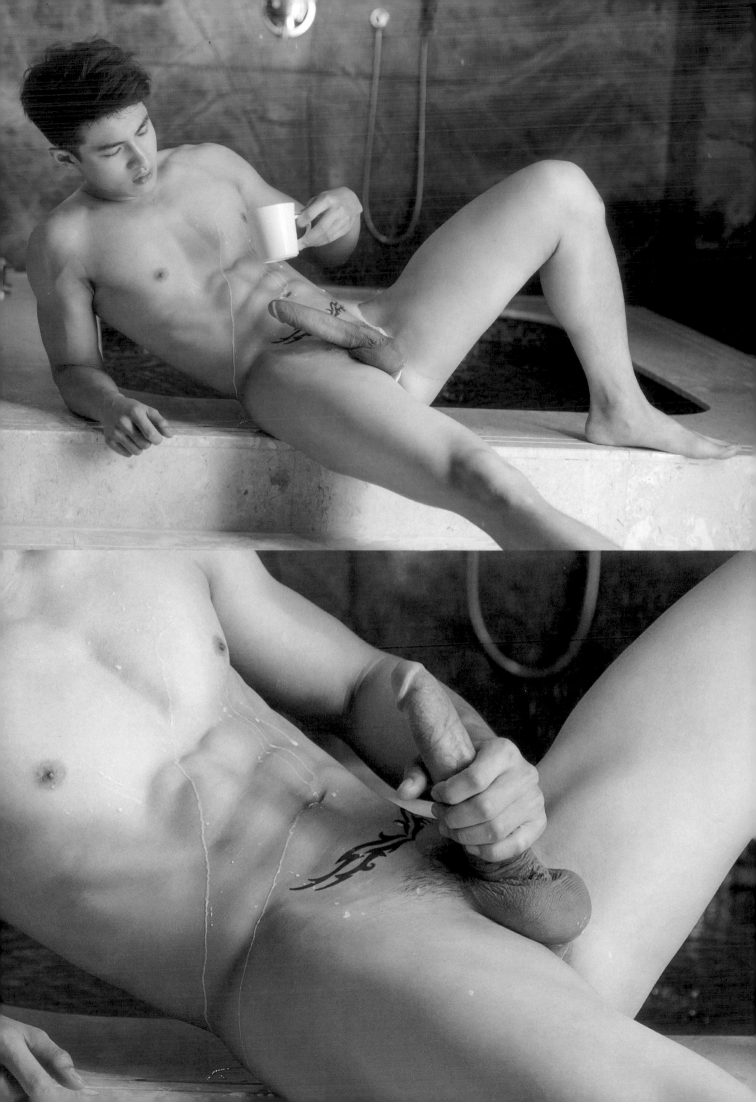

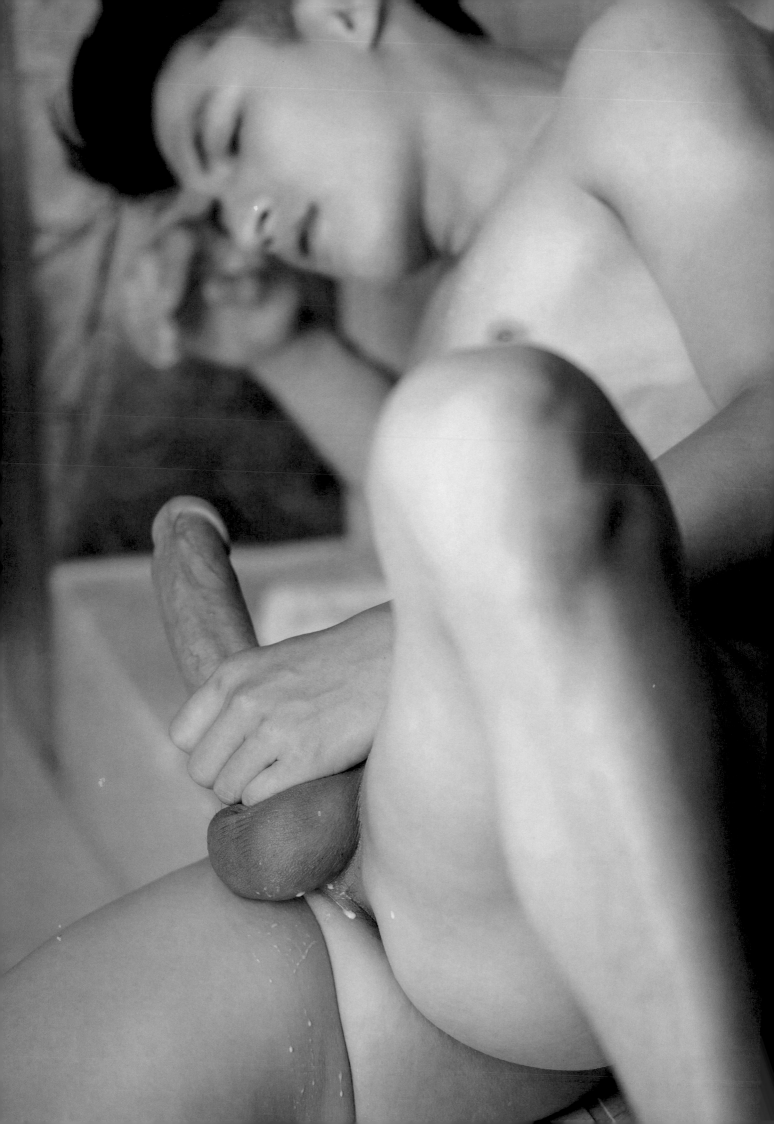

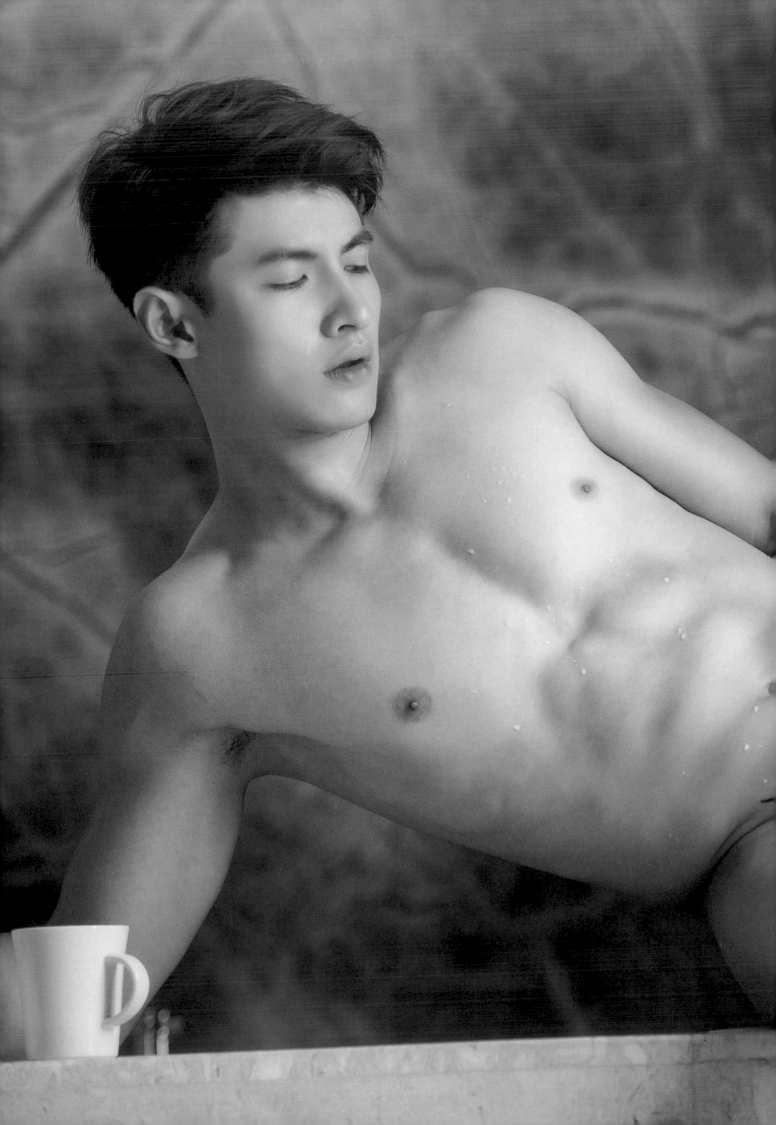

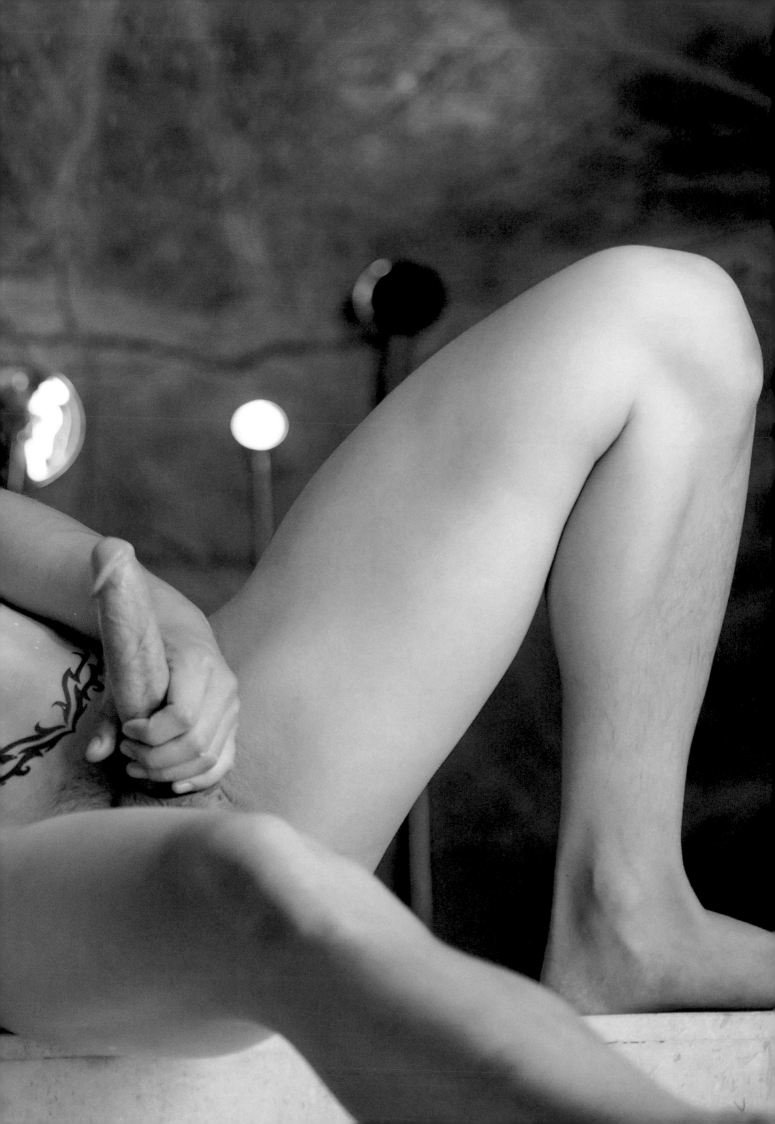

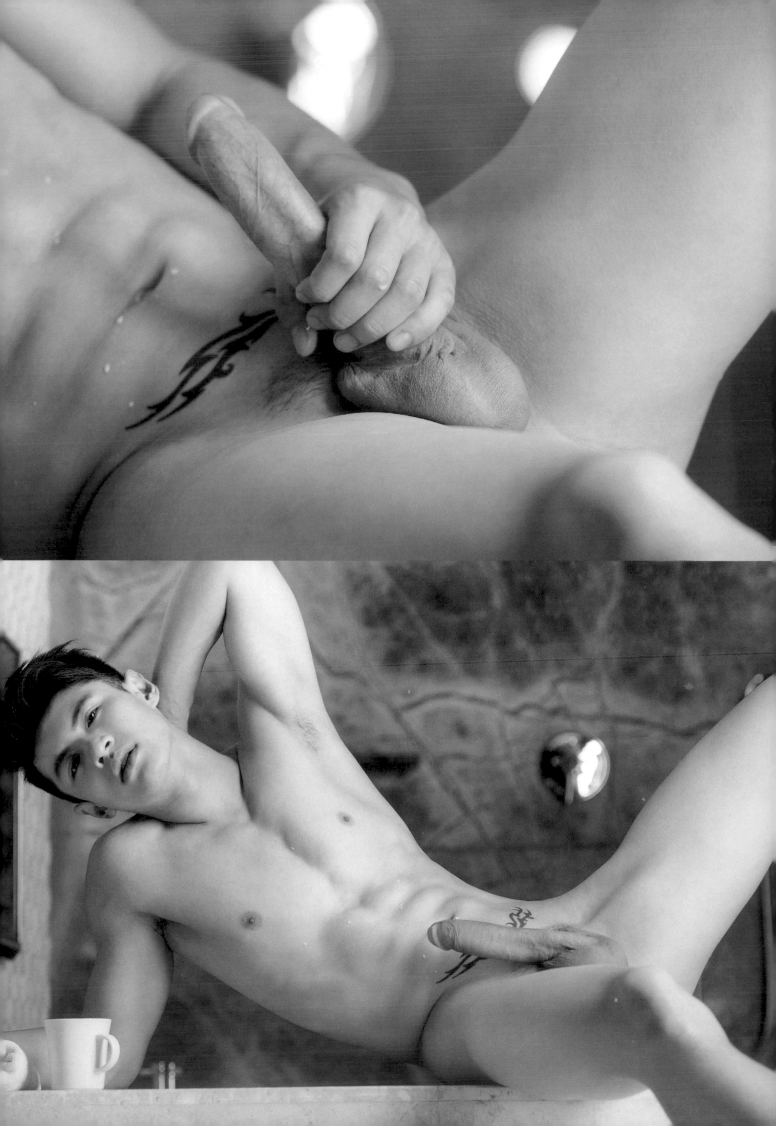

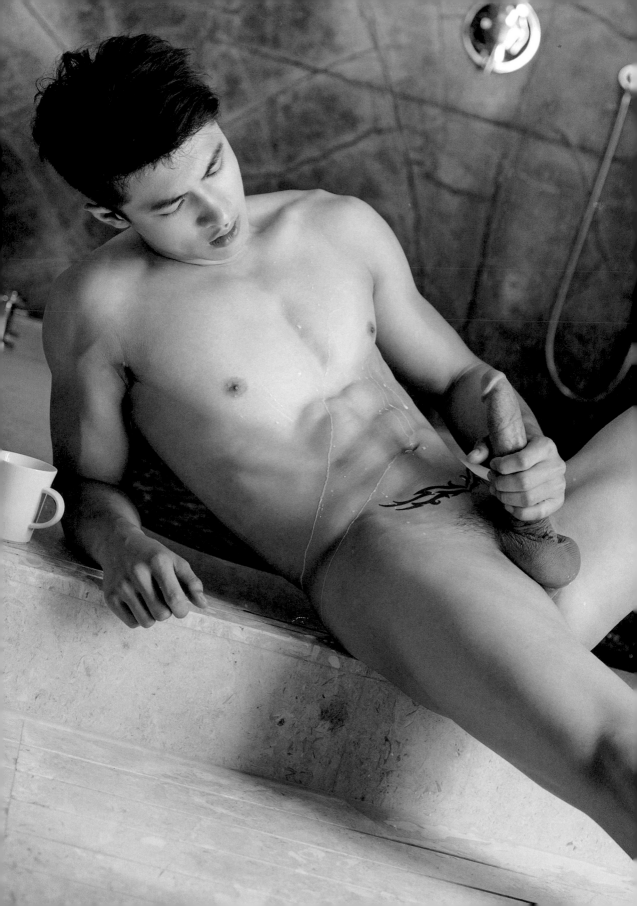

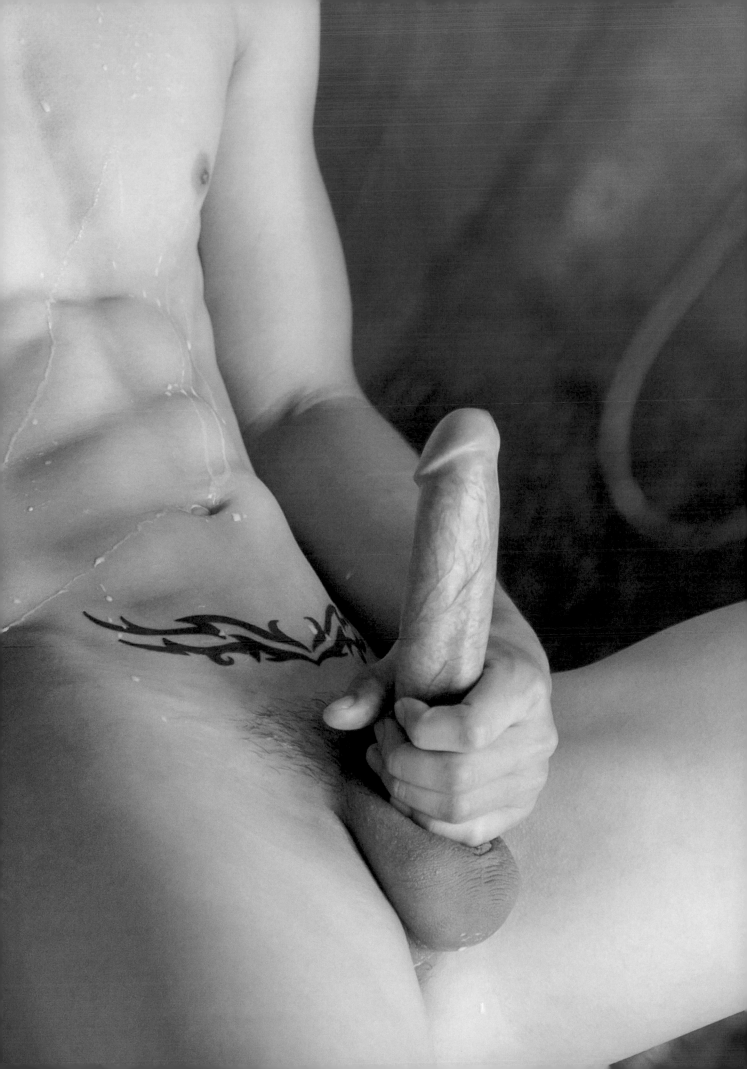

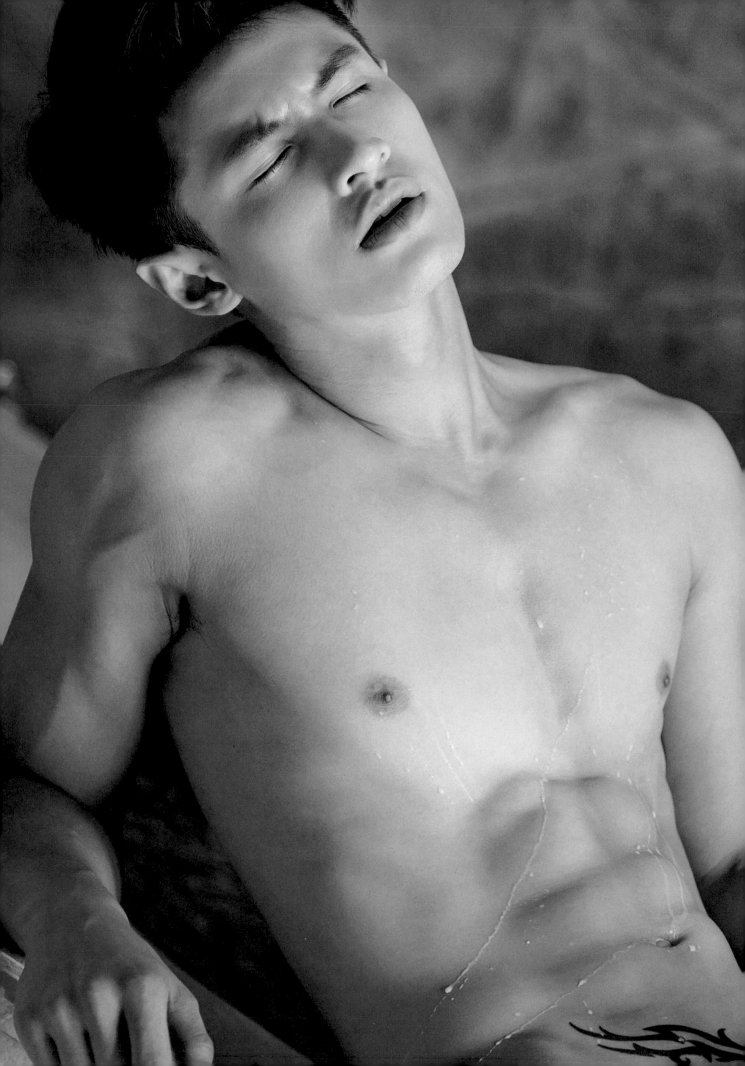

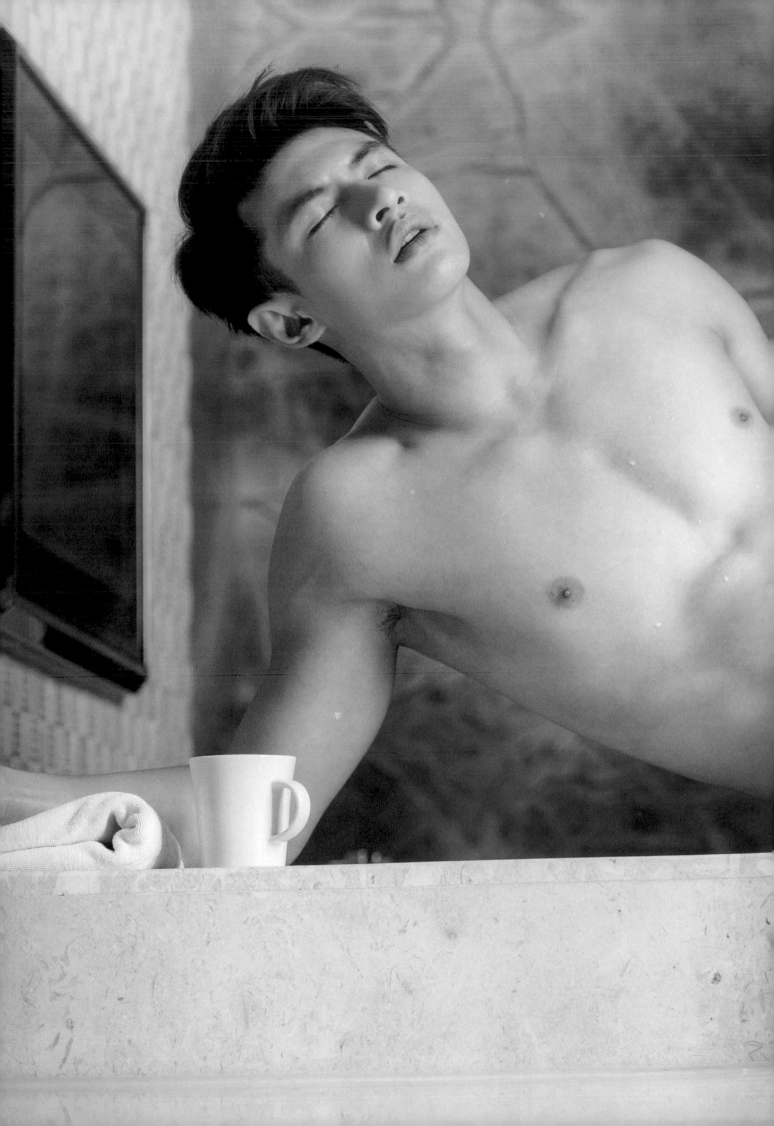

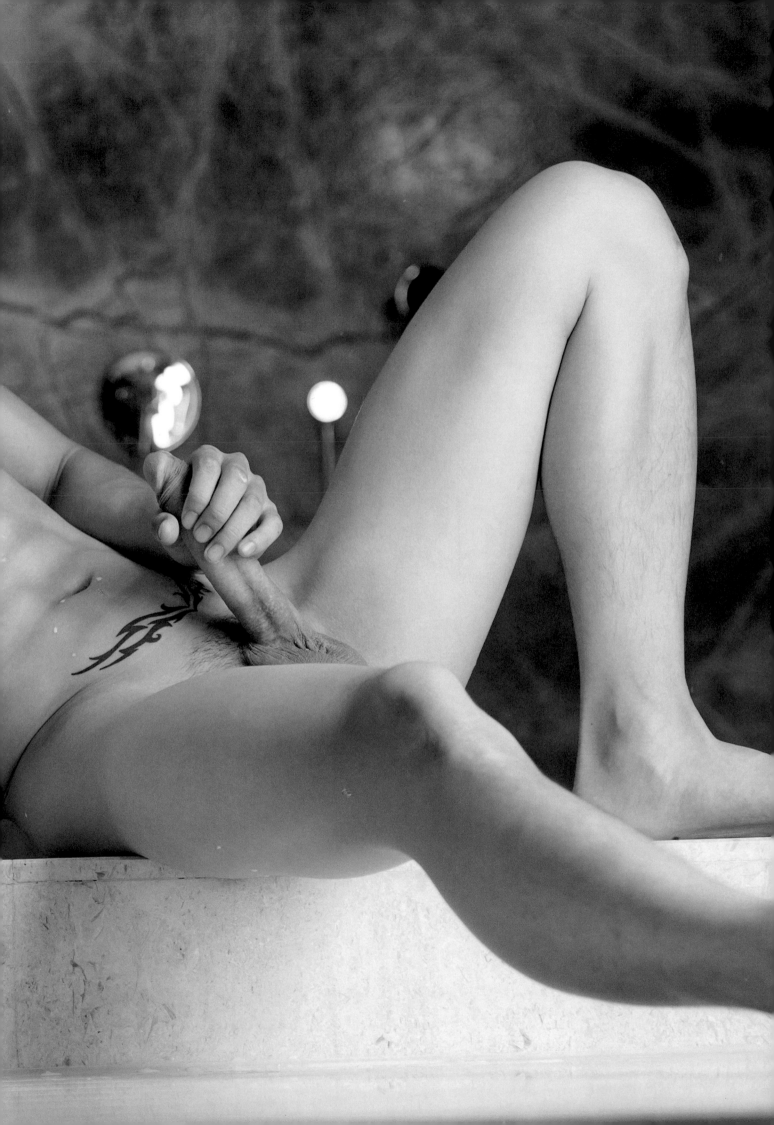

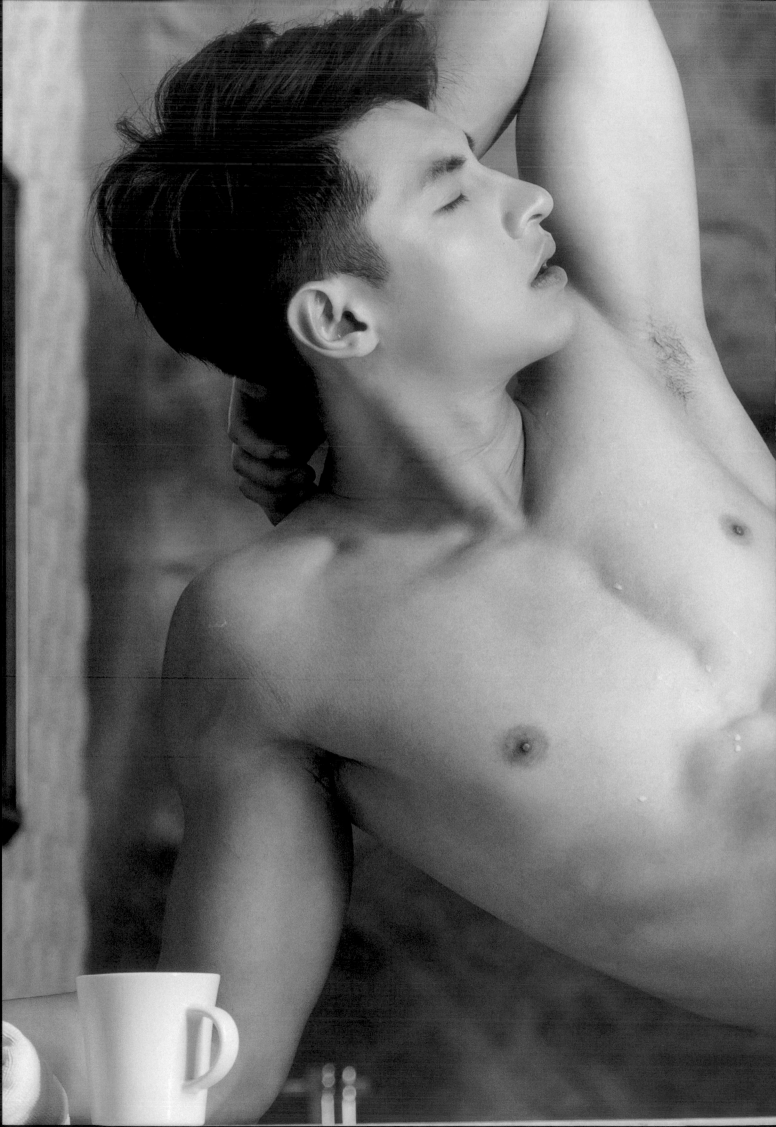

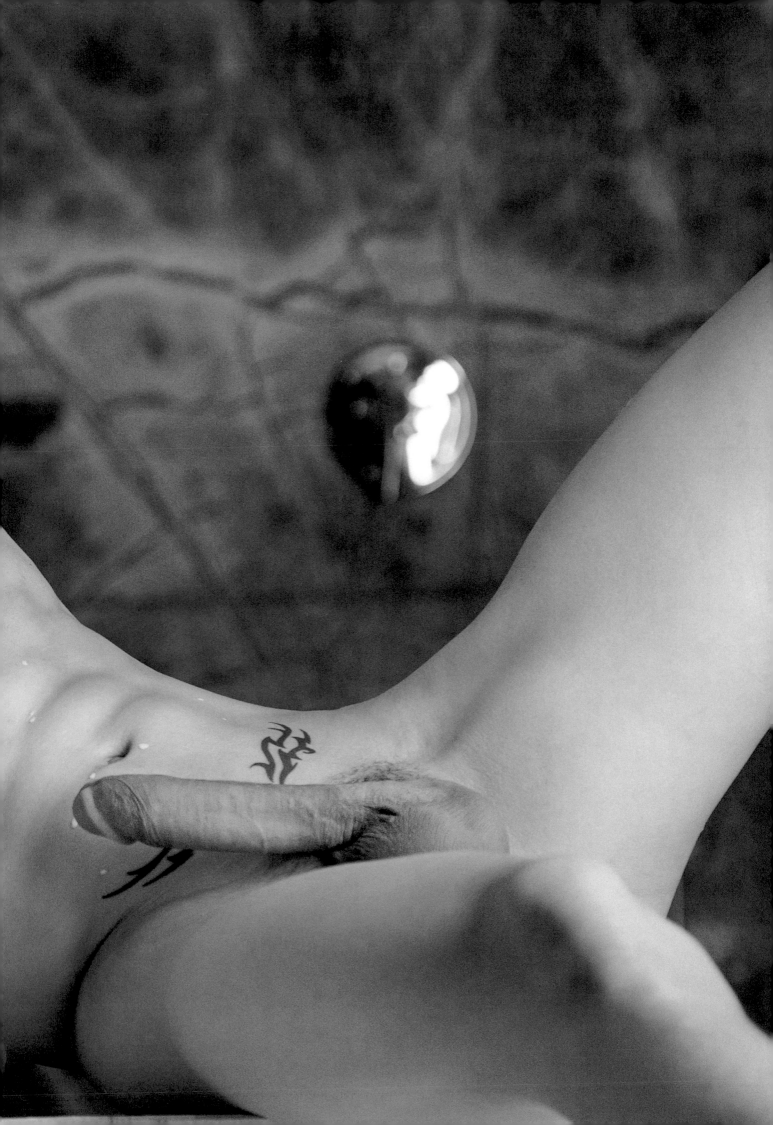

男模招募
RECRUITMENT OF MALE MODELS

身材需具有基本線條

尺度選擇
1. 若隱若現
2. 全裸全見
3. 可接受雙人或無限制

報名時請交付個人臉部及裸上身清晰照片
照片請保持清晰、不加濾鏡、並在光源明亮處拍攝
照片張數至少為5張以上

攝影師招募
PHOTOGRAPHER RECRUITMENT

徵求特約合作攝影師
無論你是平面攝影師/動態攝影師等
都能夠來挑戰看看
一起將性感時尚帶入新紀元吧

(性感寫真性別不限制男/女/男女/男男/女女)

應徵攝影師請附上作品與自介並於標題打上應徵攝影師

yasheng0401@gmail.com

@gdk5057t

f https://www.facebook.com/bluemansphoto/

https://twitter.com/a0919060483

https://www.instagram.com/bluemen183/

出版合作
AGENT DISTRIBUTION

想讓自己拍攝的寫真作品能廣為人知並有高獲利銷售嗎?
亞升出版皆提供專業寫真後期製作與代理經銷服務
無論你是平面攝影師/動態攝影師/個人作家或是相關專業人才
包含海內外網路平台銷售、大型連鎖實體通路販售等

目前已與許多知名攝影師合作出版
期待你加入我們的行列
一起為性感寫真拓展更強大的版圖吧!

想收藏藍男色 / BLUE MEN 系列電子寫真書及影音獨家映像，
你可在電子書城透過線上購買，使用電腦及手機APP進行觀看閱讀
並可隨時掌握最新期數的作品發售

http://www.pubu.com.tw/store/140780

亞升實業有限公司

搜尋書店內出版品

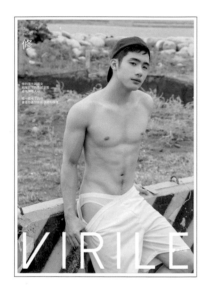

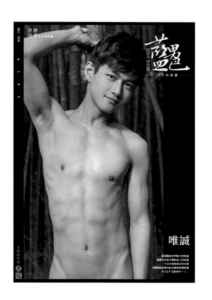

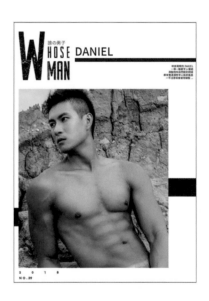

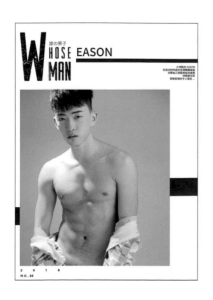

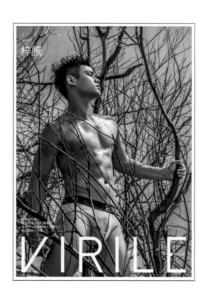

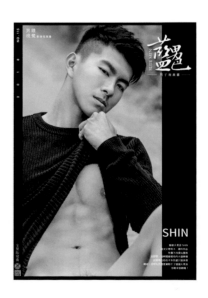

BLUE MEN
藍男色
男子寫真書

我們提供更全面的管道

讓你有更多元的選擇可以看見我們

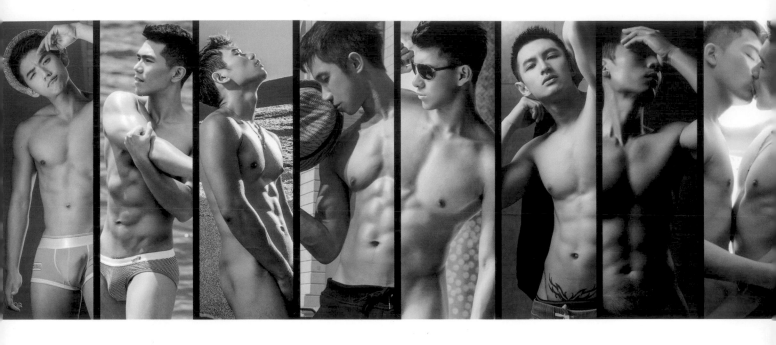

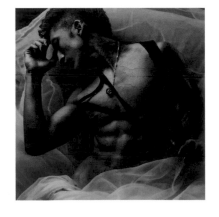

| BLUEMEN |
FACEBOOK粉絲專頁

https://goo.gl/QeFRWx

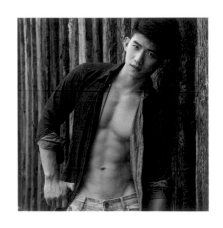

| Blogger |
官方部落格

https://goo.gl/VswZKJ

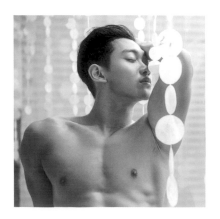

| PUBU 書城 |
電子寫真書平台

https://reurl.cc/1oxxG

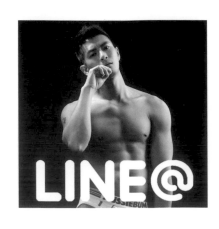

LINE@

| LINE@生活圈 |

立即加入
最即時的專屬好康
第一手的互動消息都在這裡

LINE 搜尋
@gdk5057t